Drawing the Human Body: Beginners drawing guide

Tips and tricks to drawing the human form

Stephanie Lane

Copyright©2017 Stephanie Lane
All Rights Reserved

Copyright © 2017 by Stephanie Lane

All rights reserved. No part of this publication may be reproduced, distributed, or transmitted in any form or by any means, including photocopying, recording, or other electronic or mechanical methods, without the prior written permission of the author, except in the case of brief quotations embodied in critical reviews and certain other noncommercial uses permitted by copyright law.

Table of Contents

Chapter 1 – Tools of the trade	7
Chapter 2 – Shading and Color Play	11
Chapter 3 - The Head and face	16
Chapter 4 A study of the human head and face	25
Chapter 5 - A Study of the Lips	35
Chapter 6 – A Study of the Nose	41
Chapter 7 – The Study of the Arm	48
Chapter 8 - A Study of the Leg	58
Chapter 9 - A Study of the Female Figure	68
Chapter 10 - A Study of the Male Form	89
Final Words	107

Disclaimer

While all attempts have been made to verify the information provided in this book, the author does assume any responsibility for errors, omissions, or contrary interpretations of the subject matter contained within. The information provided in this book is for educational and entertainment purposes only. The reader is responsible for his or her own actions and the author does not accept any responsibilities for any liabilities or damages, real or perceived, resulting from the use of this information.

The trademarks that are used are without any consent, and the publication of the trademark is without permission or backing by the trademark owner. All trademarks and brands within this book are for clarifying purposes only and are the owned by the owners themselves, not affiliated with this document.

You want to learn how to draw the human figure

The problem is you don't know where to start. You've looked at books in craft and books stores and have even gone online, but there are still questions and techniques that puzzle you. You've tried following the tutorials, but questions arise, and you have found steps missing in the process. You flipped back in the book to see if you missed anything and found the missing step wasn't something you've overlooked.

This book is a comprehensive guide. I will walk you through basic techniques before starting the lessons. You will be walked through steps not found in other books to help you get a better grasp on how to draw the human figure, and it's all done in an easy-to-follow format. So, what are you waiting for?

You're on your way to drawing the human form.

The most complex subject to draw is the human form. No human is the same in detail, but, at its base, it is the same. Proportions and height are the same and can be drawn with simple techniques which haven't been in other books you've read and tried to follow. This book is designed to teach you:

- The basics of shading
- The form of the head and how the features are arranged on it,
- The basic proportions of the body,
- How to add details to the human form
- How to draw the form in motion,
- How to draw expressions on the face

If all this seems a lot to take in, don't worry. Each chapter covers the different techniques. I will walk you through each of the methods and not leave you scratching your head. If you're ready to start learning, read on, my friend, and let's get started.

Chapter 1 – Tools of the trade

A doctor needs medical tools; a carpenter needs wood working tools, and you also need the right tools to break into your new hobby. Below is a list of the basic you will need to get started.

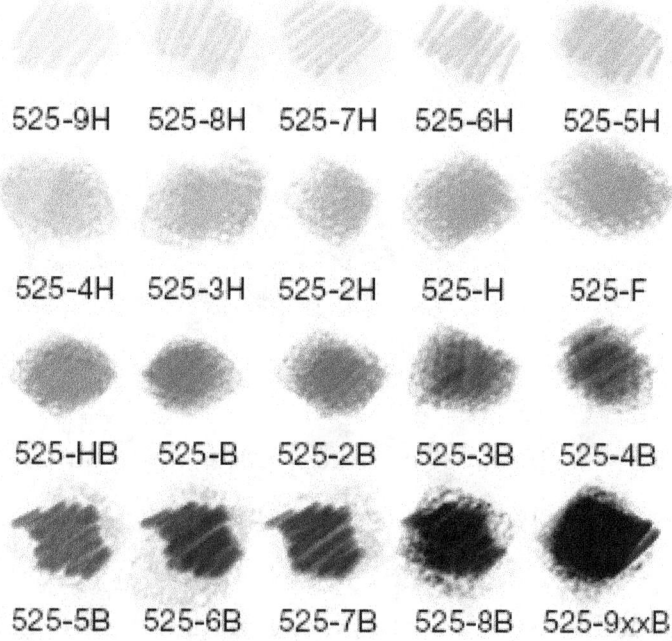

Pencils

In the art world, there are sketching and drawing pencils that are graded by the hardness of the lead. These grades all have a purpose from lightly laying out the piece to shading the figure to add in the finishing touches.

All of these grades mark the paper differently. Below is a basic chart for the different grades of pencil leads.

Pencil Sharpeners

Any basic pencil sharpener will do.

Erasers

There are many erasers on the market you can use to help you draw the human figure:

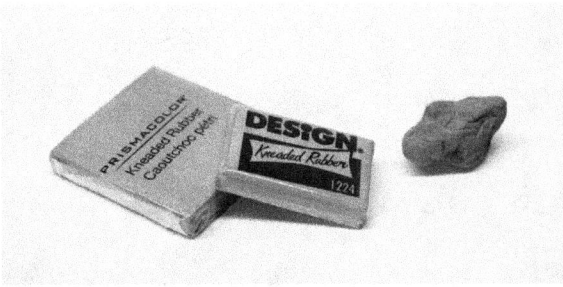

- Pink Eraser: This is the most common eraser and you can find it in any store. This erases any pencil mark on the page.

- The gray kneaded eraser can help with smudging and shading. You can pull it into any shape you want to lighten pencil marks and help with shading.

Eraser guard

To your left is a tool that can help you get rid of stray pencil marks without touching the lines you wish to keep.

Dry Erase

This can come in handy with stray marks as you work and accidental smudges caused by your hands going across your artwork. Shake it on your paper and rub it in the places you want to clean up.

Paper

There a sketch pads in different sizes you can use to get started.

Your work space

You should be seated at a desk with a surface you can tilt upward. This will allow you to draw comfortably. Your chair should allow you place your feet on the floor without having scoot forward in it, and your chair should be comfortable enough for you to sit in for long periods of time without your legs going to sleep or you're back hurting.

Felt or fine tip marker

If you wish to immortalize your work of art, inking pens, felt tip pens, and even an extra fine Sharpie can help. I would suggest starting with the most economical until you get the hang of it.

Blending Stumps

To the left are blending stumps and they are usually sold in packs. They allow you to blend shading easily.

Chapter 2 – Shading and Color Play

Nothing brings a figure to life than shading it just right. Shadows and shading correctly can make the figure come to life and give it depth and character. In this chapter, we will go over the basics of shading and the technical aspects behind them.

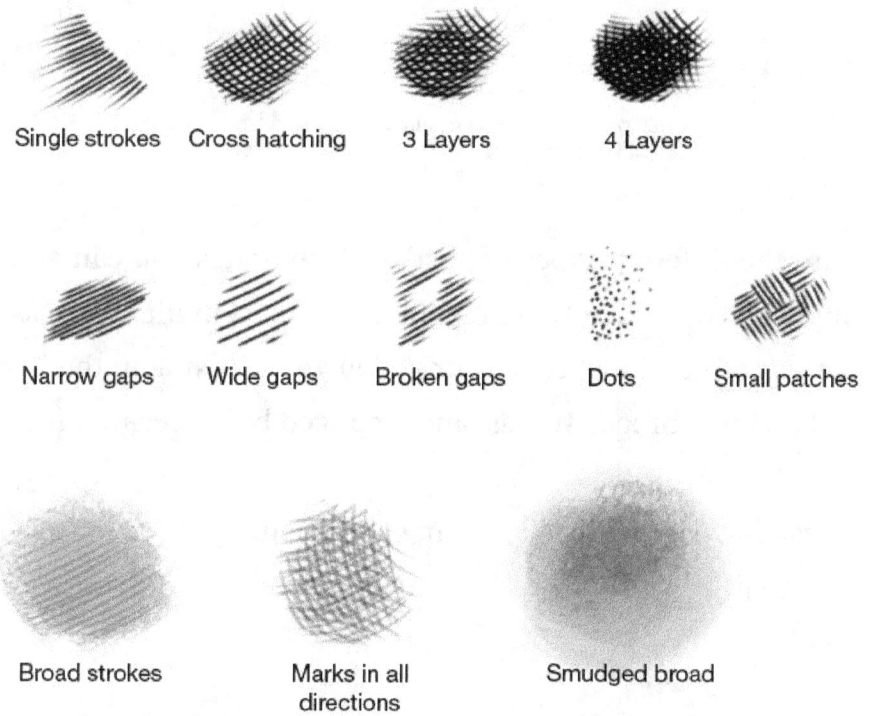

Shading techniques

To the left are the different types of shading techniques you can employ in drawing your subject. Each of these techniques is used in different cases and in different areas of the drawing. The ones you will be using in these lessons will be cross hatching, broad strokes, and smudged broad techniques.

Dots can be used in cases of neck shading and shading between fingers and other digits as well.

Textures in shading

These textures can be used to enrich your drawings and can add details without having to draw them in so they are dark. Grading, for instance, can tell the person who is looking at your piece of art how far the light is away from your subject and at what angle the light is at.

Light source

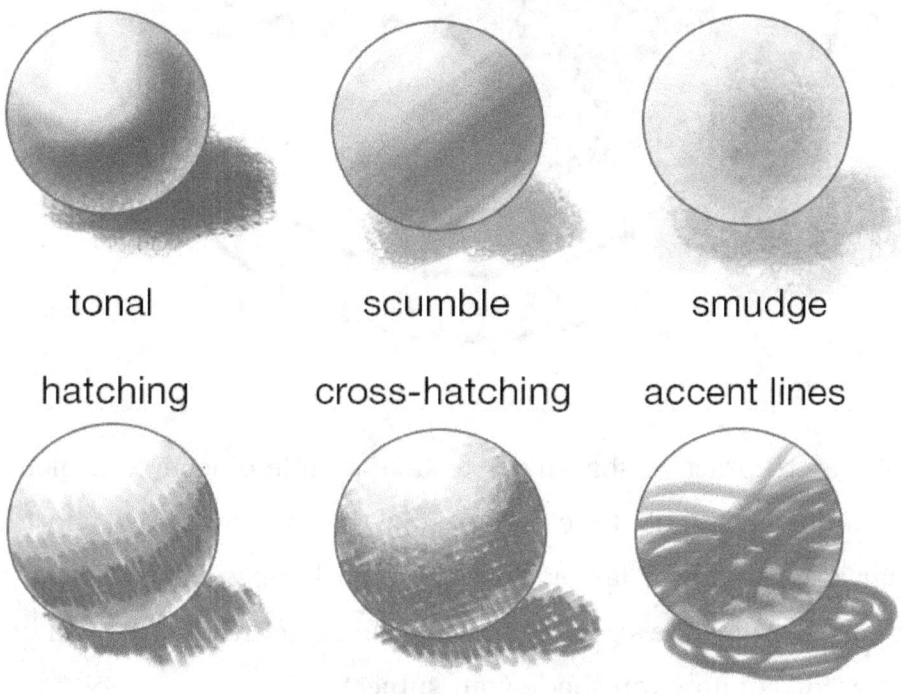

Here we have incorporated some of the shading techniques to show you how to shade according to where the light source is. The light source is top left, and you can tell from the lightest spot on the sphere. As more and more of the light is blocked by the sphere, the shading gets darker and darker until the light is completely dark at its base.

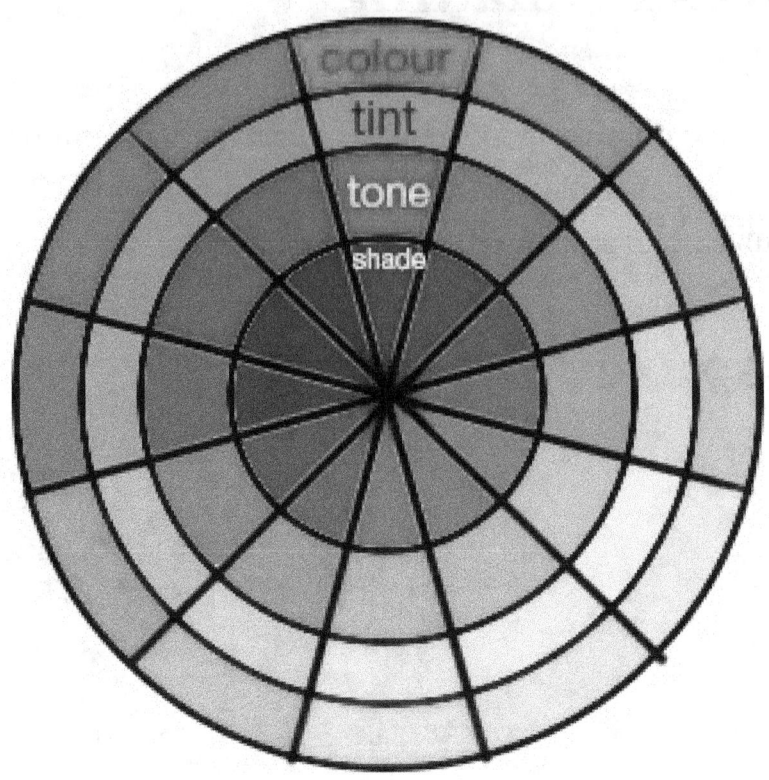

The best way to practice shading is to take simple objects and place them under an adjustable light. Take note of how the shadows grow, shorten, and disappear according how far or close the light happens to be to the object. You can also see how the shadows play on the object itself. This will help you get a better idea of how you shade your subject.

The Color Wheel

We first were introduced to playing with colors when we were young. Crayons and coloring books allowed us to combined colors and even use colors we've never seen to add hues to the pages and characters on them.

What we didn't know was that we were being taught how to use colors.

How to read the wheel

The primary colors are north, south, east, and west. Complimentary colors are to the left and right of these primary colors. They work with the primary colors to add richness and depth. The colors across from the primary colors are contrasting colors. These combinations are used to highlight details and bring attention to certain details. The closer you get to the middle of the wheel, the darker the color. This is to aid in the shading process.

Chapter 3 - The Head and face

The multi-faceted features of the face can be daunting. If you don't get the features right, the face looks off or alien. It isn't pleasing to the eye. Add to this moving the head and adding expressions and you've got a frustrating part of the body to draw and get anatomically correct.

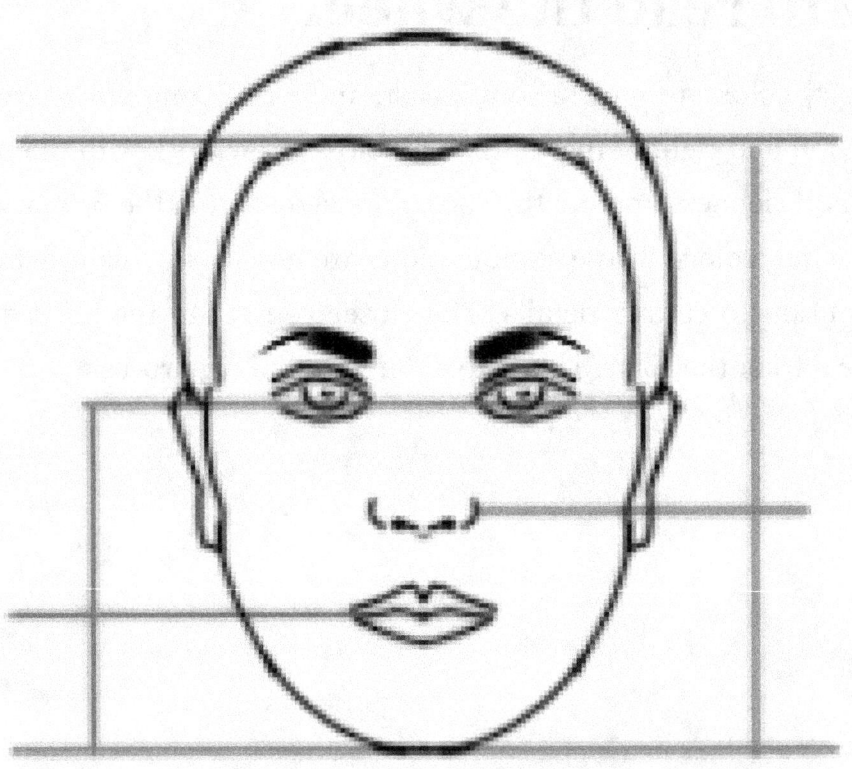

To the left, we see a basic, male head. Think of the start of this head as an oval and draw it on your paper.

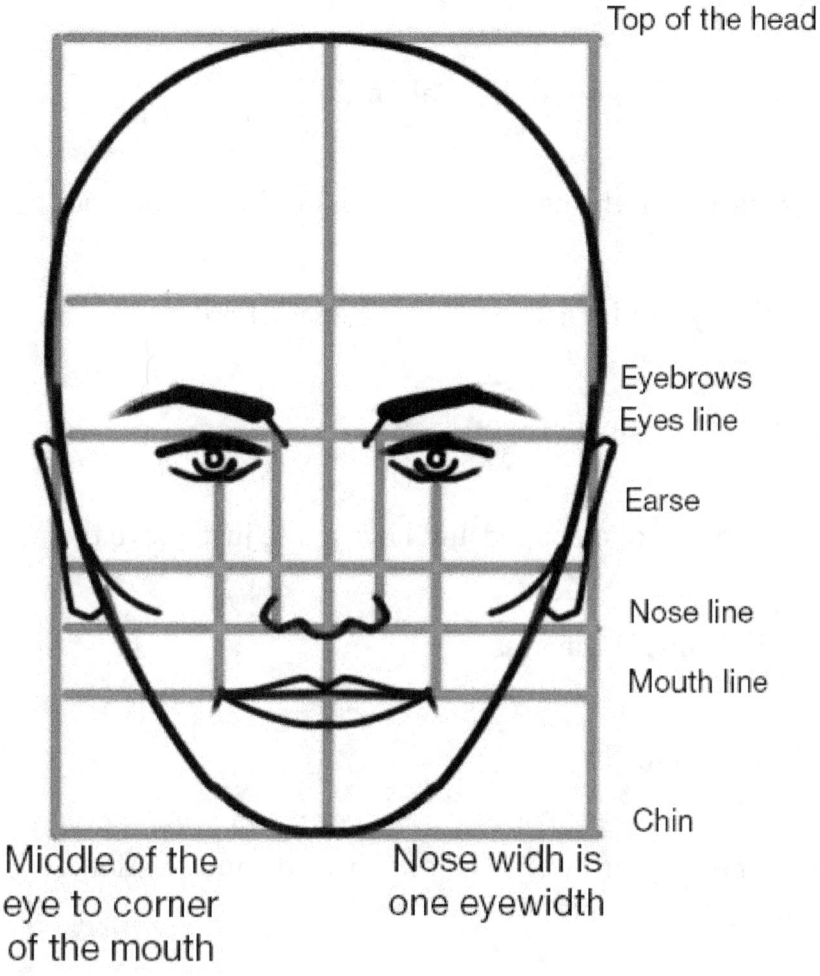

1. Now, cut this oval in half, and you get where the eyes go. Draw this line.

2. Now, break the bottom half of the head into thirds.

3. One third of the way down draws a line for where the nose would go.

4. Draw another line two-thirds down and place another line where the mouth is going to go.

5. About a quarter of the way down, draw a line for the hairline.

6. Now, draw a circle around the oval for the hair.

7. The ears start from the eye line and stop just below the nose line.

8. Between the eye and nose line, add the cheek bones.

9. Add the curve for the hairline.

10. The eyes are almond shaped and have a line just above them.

11. Add the circle inside the eyes.

12. Add the eyebrows.

13. Add your nose by draw one "C" on both side and the dots for the nostrils and a small "V" for the center of the nose.

14. Draw the mouth.

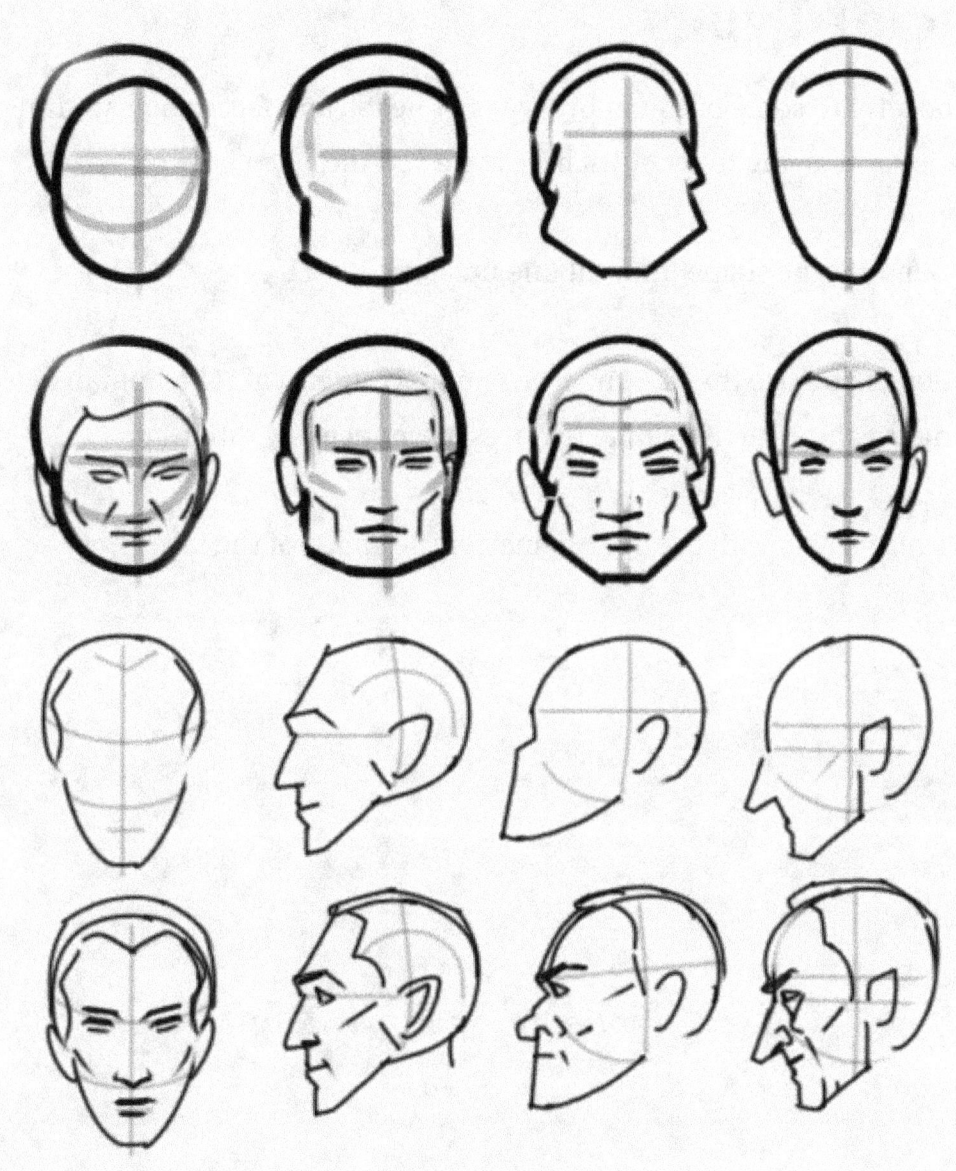

Facial Types

To the left are some of the many types of heads and faces you can draw with practice and laying them out. There are a few things to notice;

1. No matter the shape, they all line up along the "T".

2. Though you use the "T", the face is not symmetrical. The human face isn't symmetrical in real life. Some features are noticeably different.

3. The ear aligns with the eye, no matter the shape of the face.

Tilting the head

When you get into the habit of using the "T" to line up your facial features, you will start to play around with how tilting the "T" will change the direction of the face of the whole. It makes lining up your features easier when tilting the head and making expressions.

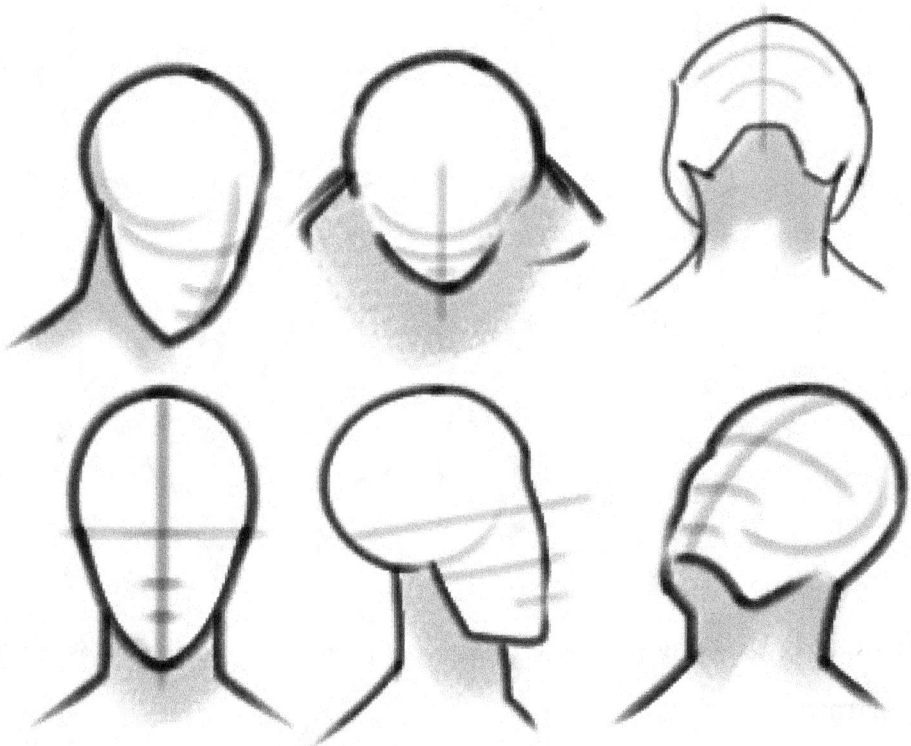

Features and the Profile

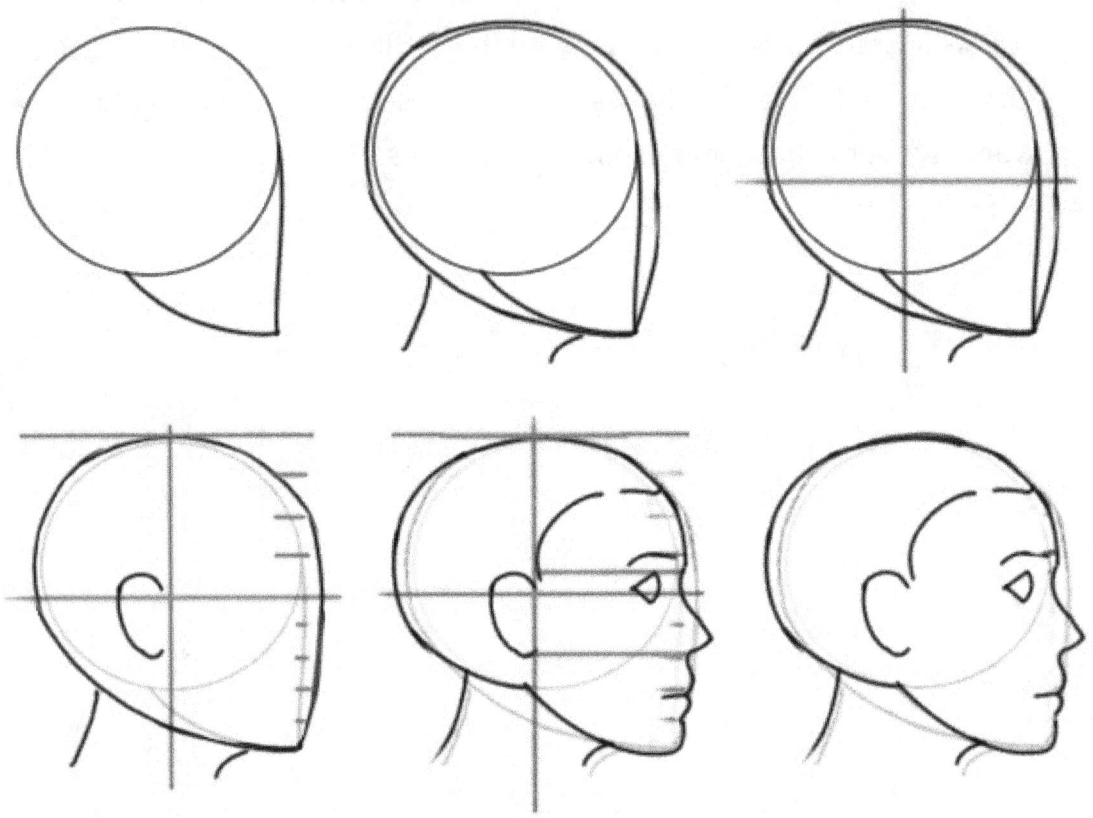

You will inevitably want to draw someone from the side; this is called a profile portrait.

1. Draw a circle.

2. Draw a backwards "L" shape, with the bottom curved.

3. Outline all of it with curves you see in the next step.

4. Add in the two neck lines.

5. The "T" here is different, but it's the same concept as drawing the face from the front. Just add the lines as you see them.

6. Add the features starting with the ear and then the hair line.

Body Proportions

In order to draw a convincing body, you need to be aware of how it is measured and portioned out. The height of the body is measured in head height. The width of the hips is also measured by head height, but the difference is that you would turn the head to the side to get the correct width of the hips.

To the left, is a chart of how to proportion the body according to height? As you can see, an extra head add to the height of the figure as a whole.

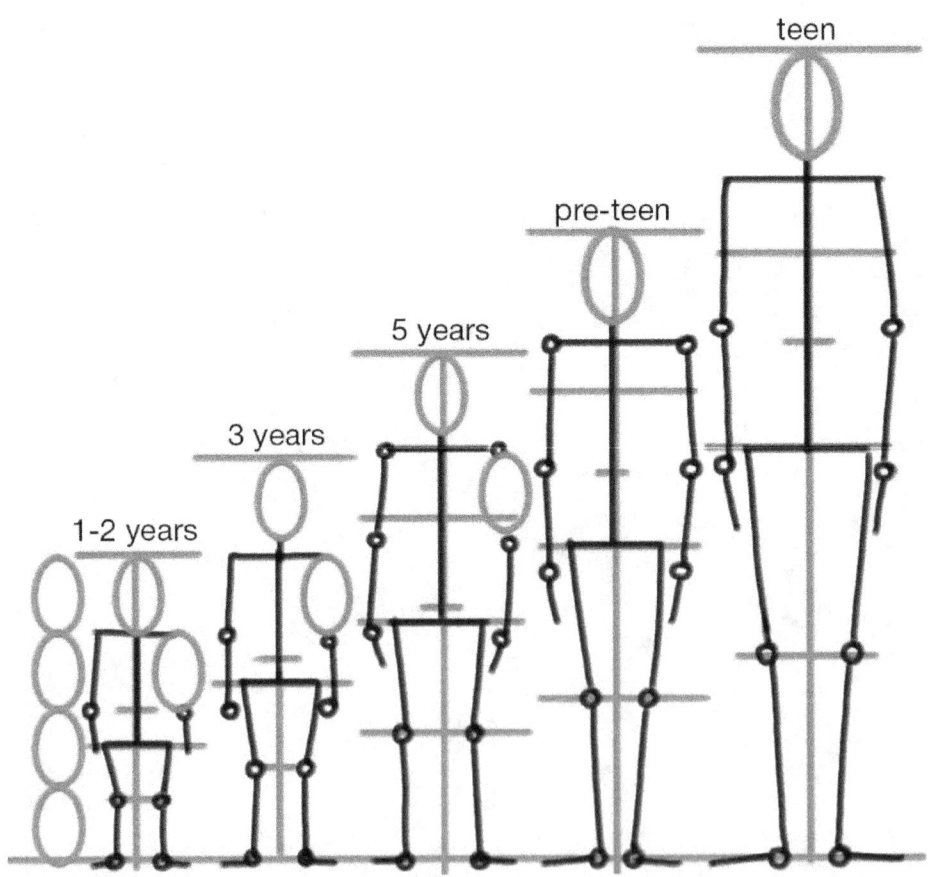

Chapter 4 A study of the human head and face

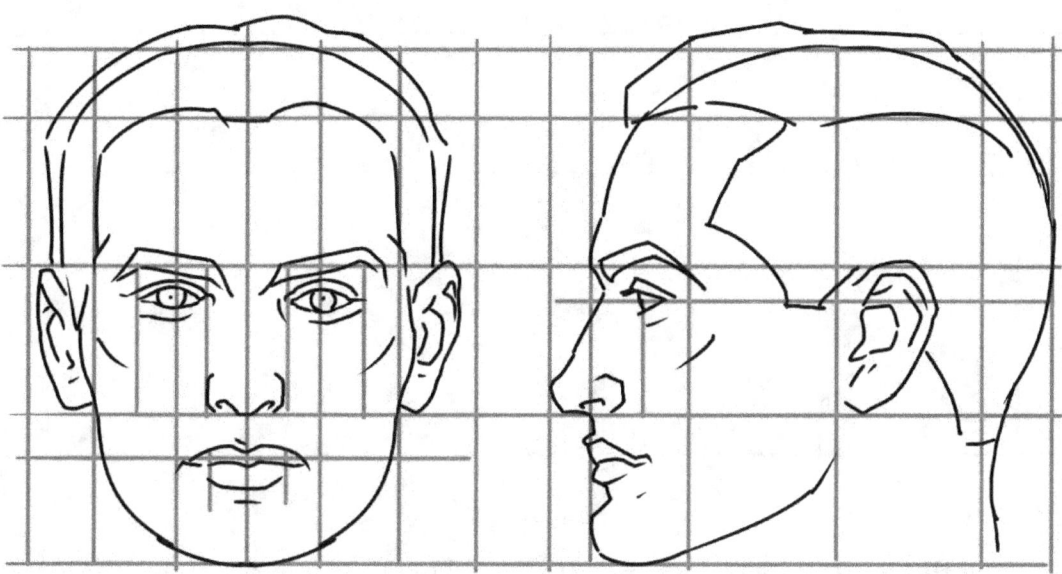

We've covered the basics, and now it's time to delve into drawing the human form in earnest. We're going to start with the head and work our way to the body as a whole.

For the face, we have drawn the template for the face and then added the features.

form layout for future picture

1. Using the hardest lead possible, draw the layout as you see it to the left.

form more detailed layout for facial features

2. Now, add the lines for the facial features.

create the form of brainpan

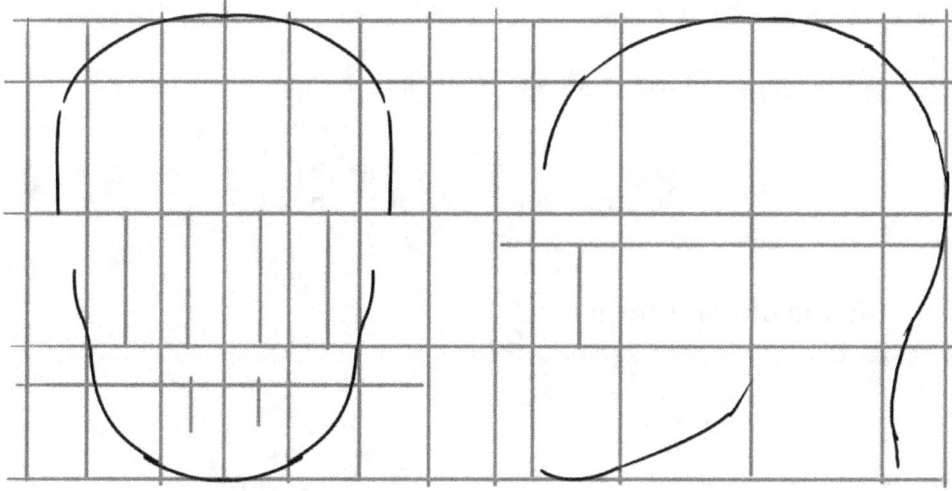

form layout for nose and eyes

3. Add the guides for the nose and eyes here.

5. Start with the left side of the layout. Add the top of the head.

6. Now, add the lines for the side of the head.

7. Add the bottom of the head.

8. On the right side, draw the curve of the head.

9. Add the lines for the chin.

form facial features and line of eyebrow by layout

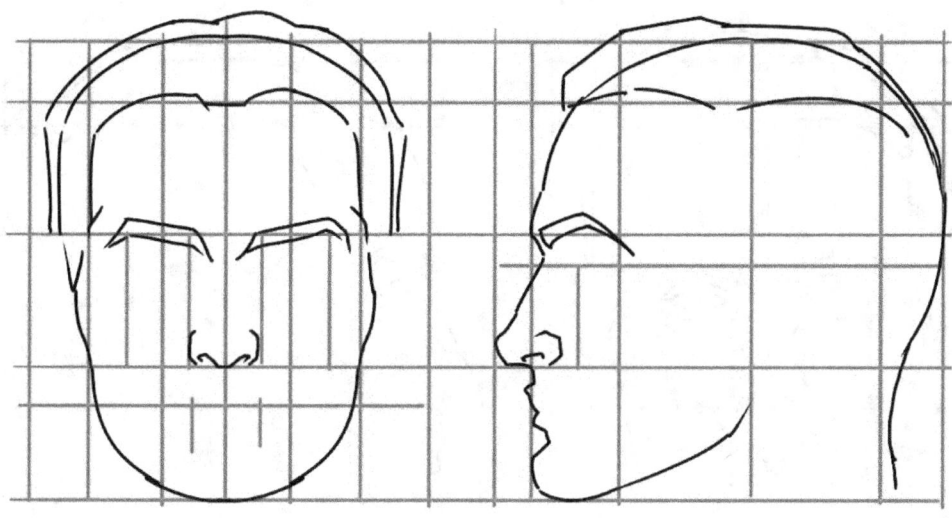

9. On the left of the layout, add the hair line.

10. Add the lines for the hair.

11. Bring the sides of the face up closer to the eye area.

12. Add the eye brows.

13. Add the nose.

14. On the right, add the side of the hair line.

15. Add the curves for the forehead.

draw thr form of eyes, specify the form f hair

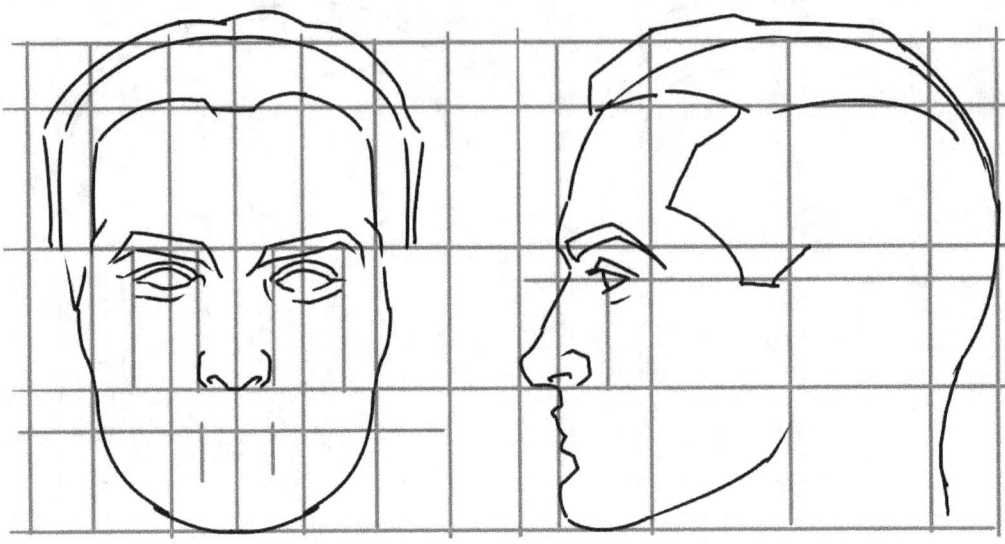

16. Add the nose, keeping inside the guides for the nose.

17. Add the curves for the mouth.

18. Add the chin.

19. Flesh out the hair on both of the sides.

20. Add the eyes according to the guide. Start with the main part of the eye and work outward.

add cheekbone

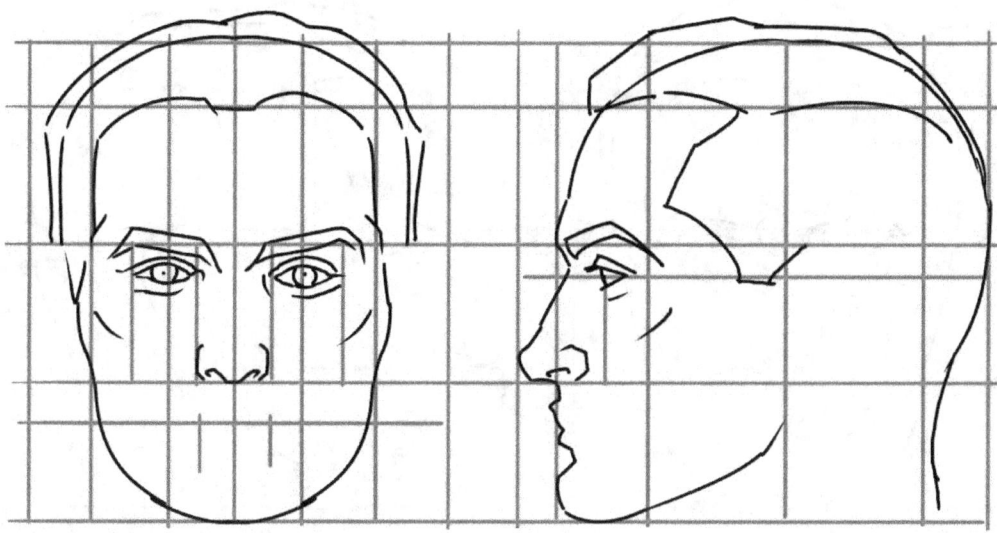

21. Here we add the cheek bones.

22. Add the cornea of the eye.

23. Add the lines under the eye for the bags.

24. You will note on the right half, the eye looks more like a "V". This will make it easier to draw the eyes and add details to them.

25. You can also see where we have put the cheek bones in relation to the profile.

add ear auricle

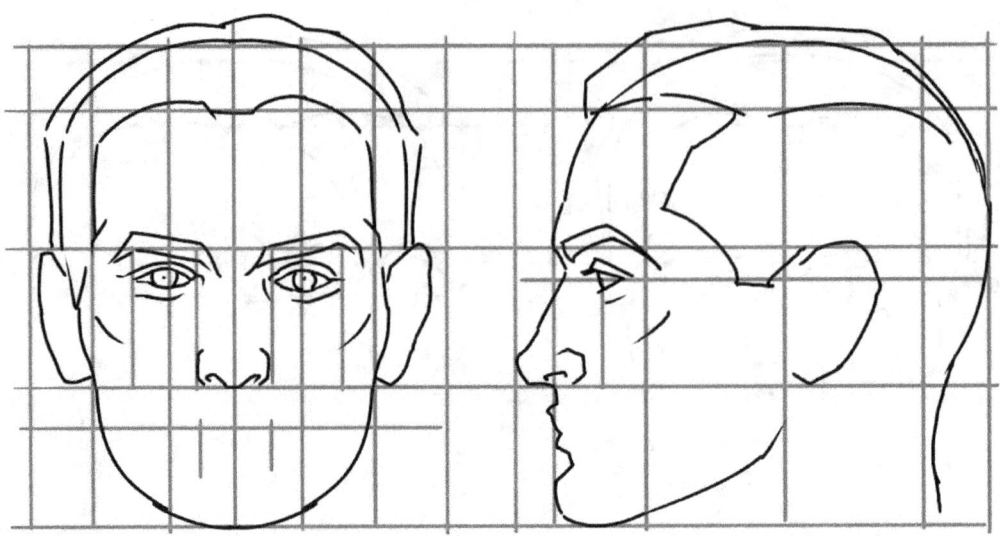

26 On the right, you can see where we have added the ears.

27. On the profile, we've drawn a sweeping curve for the outside of the ear.

28. On the left, we add our first curve starting from the closest to the edge of the ear.

29. We will now add the curve which is the bump inside the ear.

30. Finally, we add the smaller details.

31. On the right, we've worked from the outer part of the ear to the inner part once again.

add lips

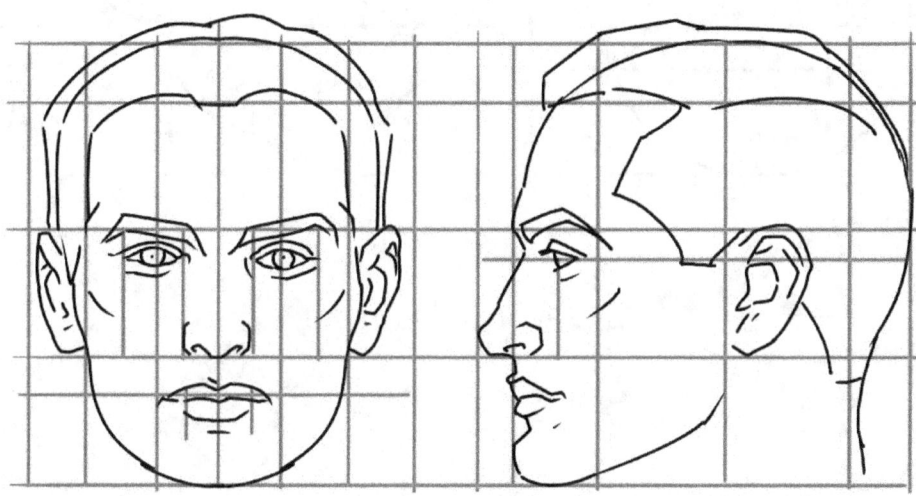

32. The last thing we added was the smaller details.

33. The mouth is added to the left side first with first drawing the curves of the top lip.

34. We then add the line for where the lips come together.

35. Now, add the bottom lip and the line underneath.

36. On the left side, we bring in the lines of the mouth starting from the top lip and working your way down.

form the construction of ear auricle

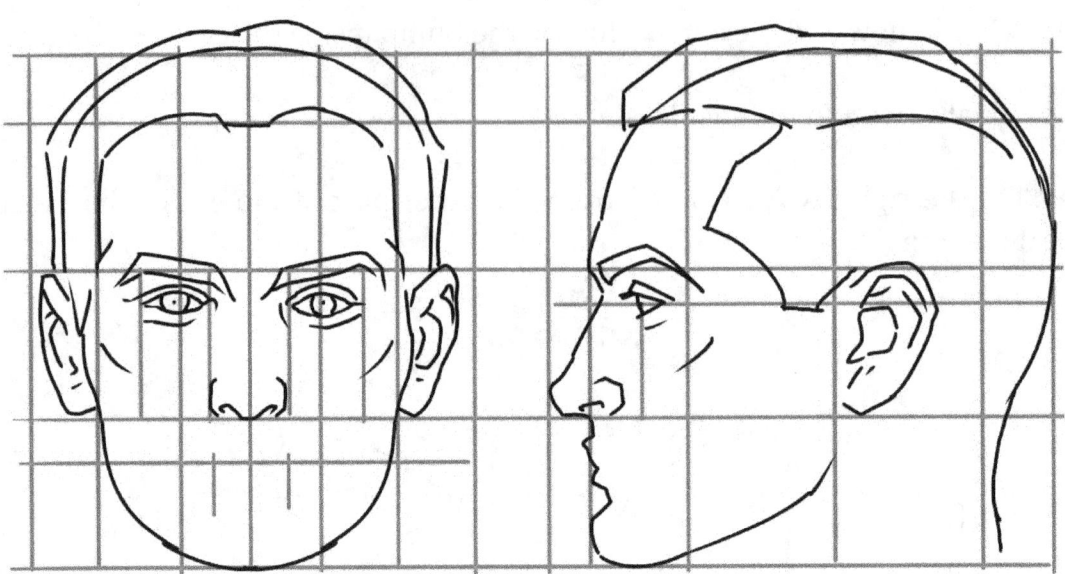

Chapter 5 - A Study of the Lips

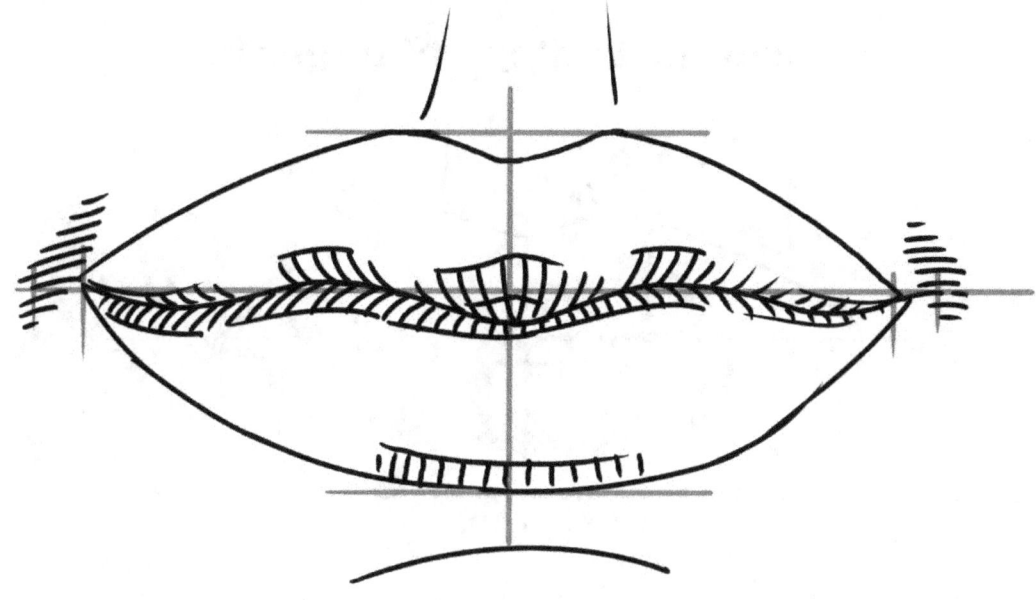

We're taking a closer look at the lips in this chapter and lesson. They look pretty simple to draw, but if you're not careful, it can be the one feature which can ruin a drawing when doing a close-up of the face.

1. This is the basic layout for the lips. You can use this for practice in future pieces.

form layout for lips

2. We are adding small dashes to help us form the guides for the curves of the lips.

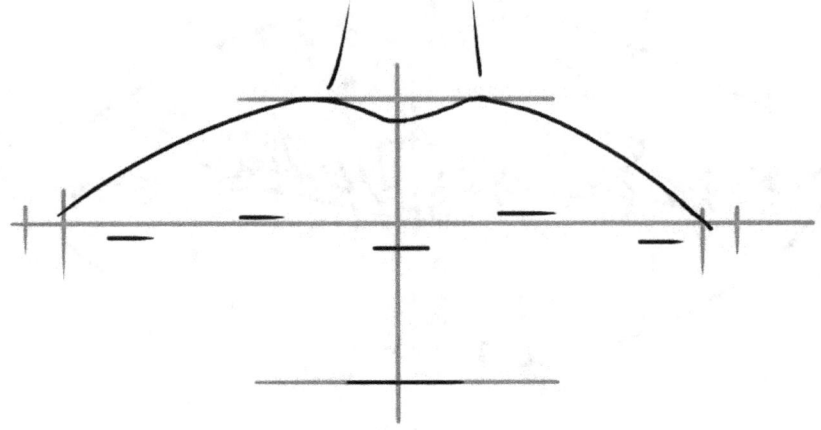

form the contour of upper lip

specify the form

3. Here we see where we put the curve of the contour of the lip.

4. From there, we add the curves on either side of the contour.

4. We add the dashes above the lip for the dip between the nose and mouth.

5. Now, we're using the earlier dashes for the curve between the lips.

draw the contour of lips joint

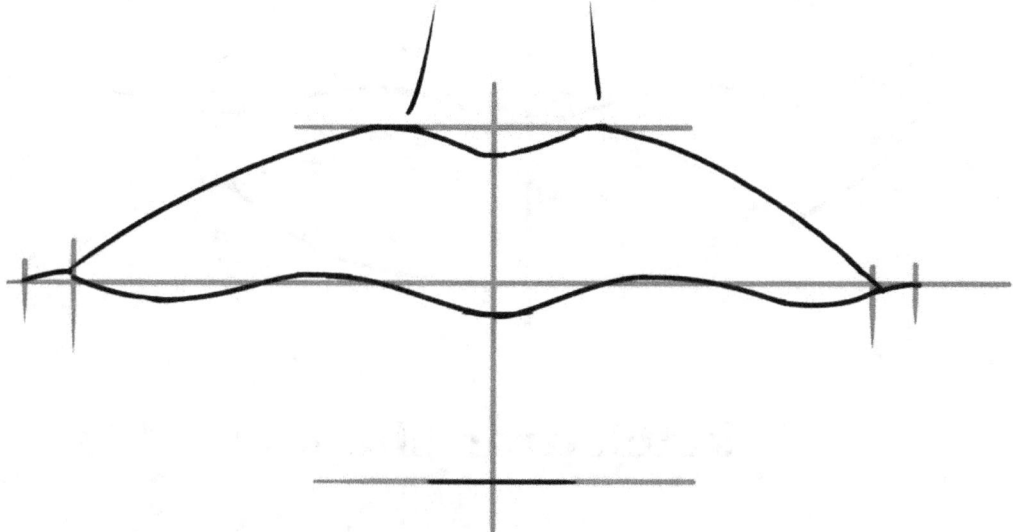

6. Here, we add the bottom curve of the lip.

add the contour of lower lip

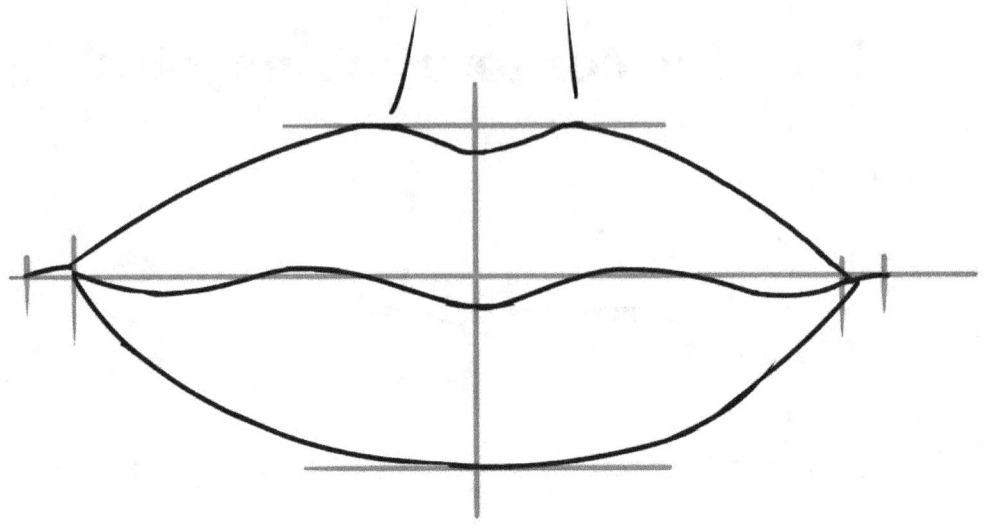

sketch drop shadow

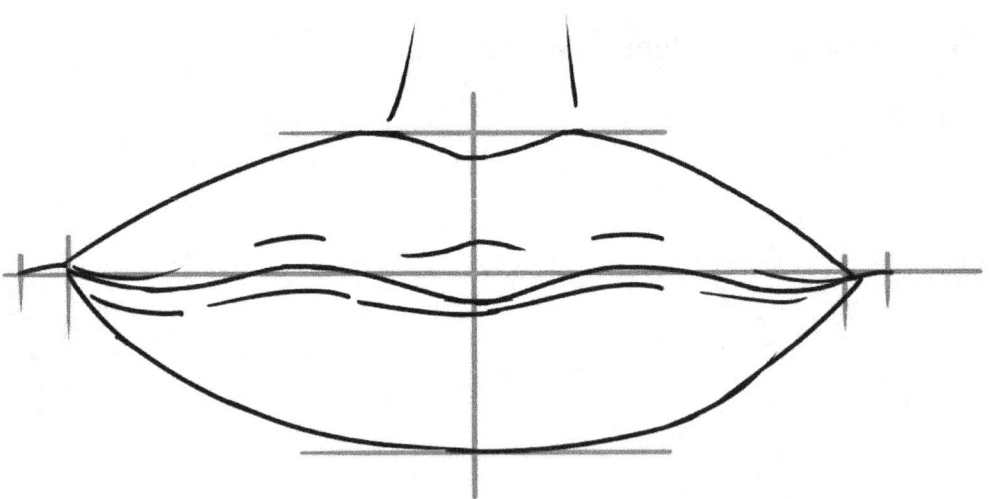

8. Add the extra curves of the lips here.

9. We use hash marks here for shading the lips.

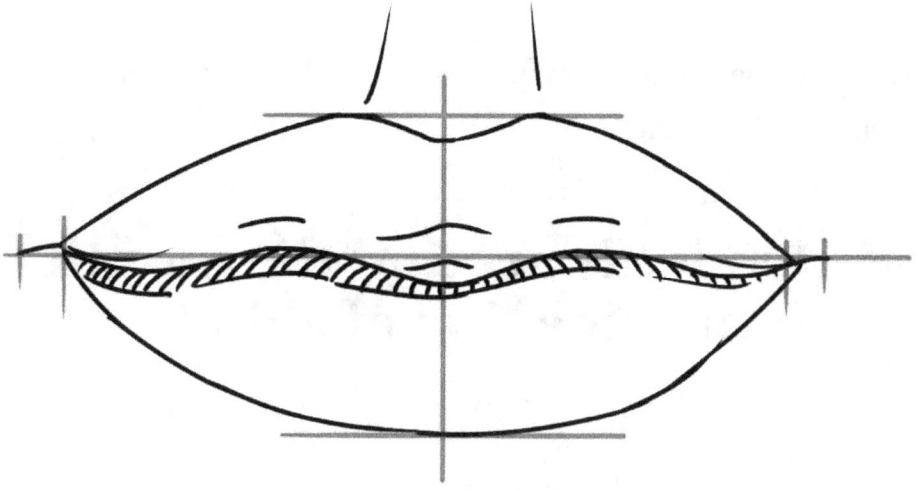

hatch shaded area

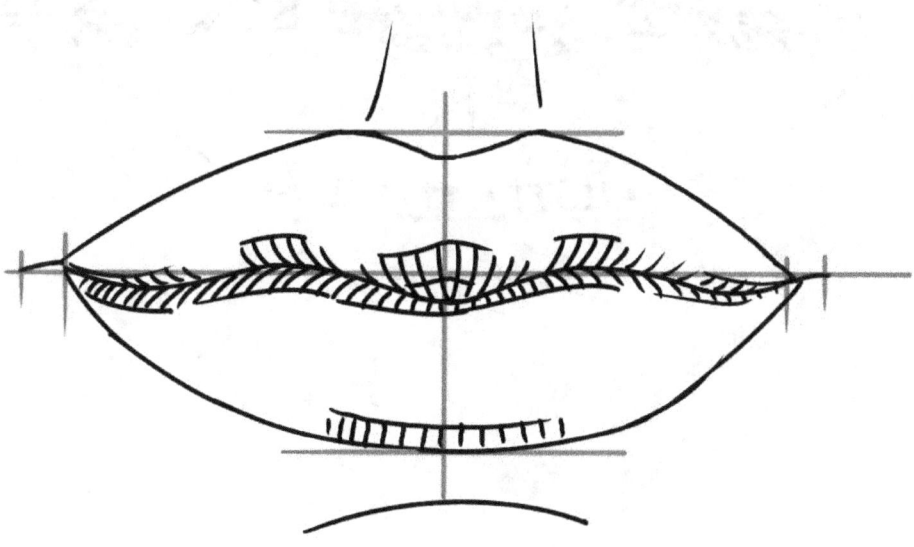

specify the form of lip

10 We're further specifying the lips by shading them a little more.

11. We have also added the curve under the lip.

Compare what you have done so far and add in the details you don't have on your lesson. You're doing great.

Remember, no one perfect from the start. Even the most notable artists took years to master their craft.

sketch folds around the mouth and the line of chin

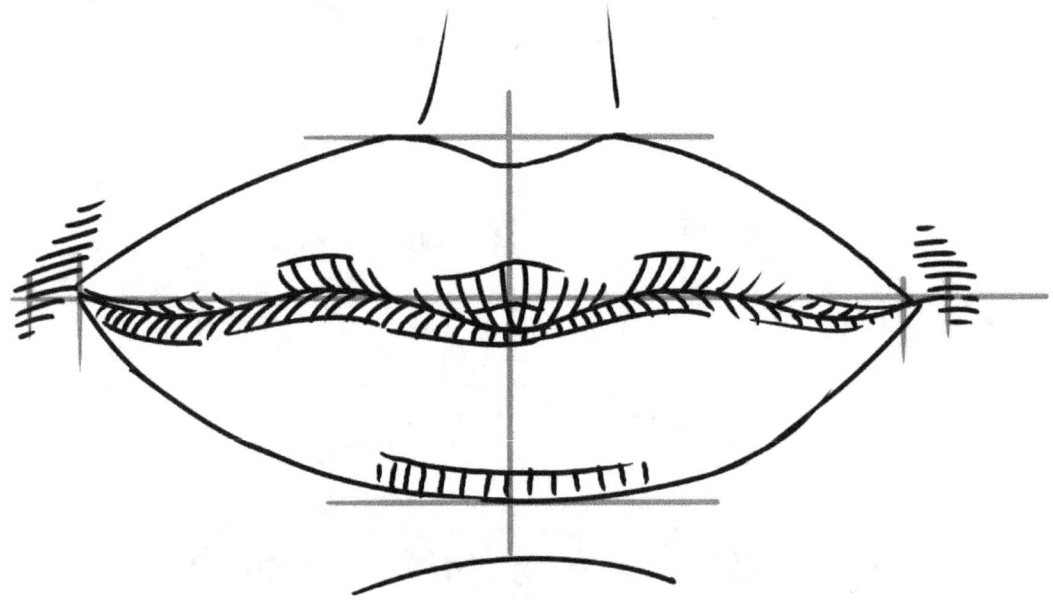

Chapter 6 – A Study of the Nose

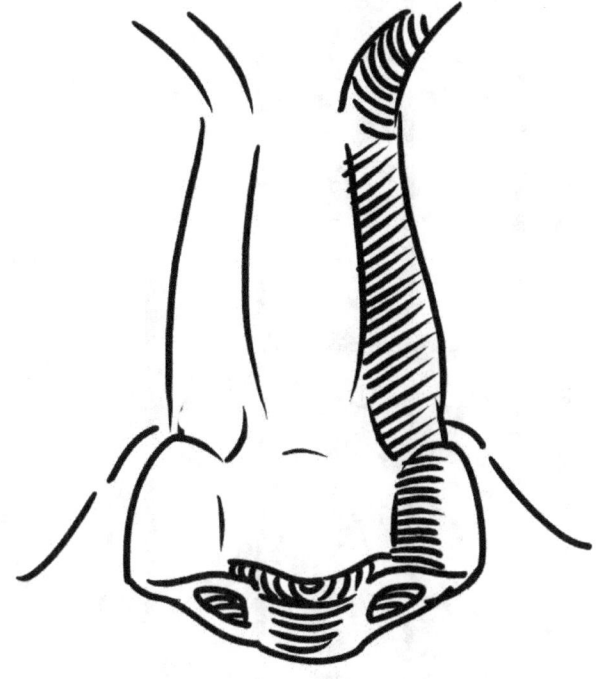

We're going to focus on the nose for this lesson. It can be one of the most daunting features to get right when drawing a face. Though each nose is different and portioned to each individual face, this lesson will help you form the nose a little easier.

form layout for nose

1. This is a basic guide for practicing the nose and all the details.

2. Using the guide, we first add the curves that lead to the eyes.

sketch nose tip, nose alae and basis of brow ridge

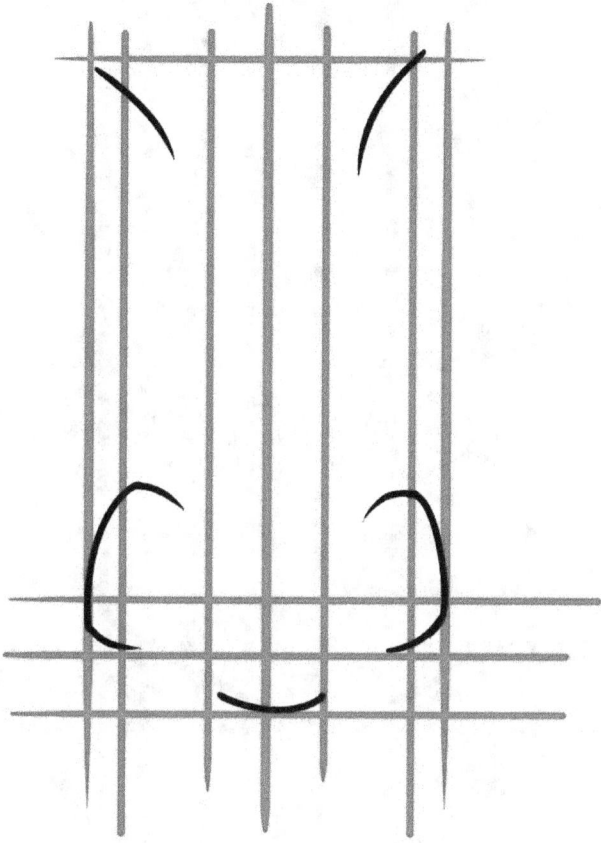

3. We now add two "D"s without the finishing bar for the nostrils.

4. Finally, we add the curve for the point of the nose.

form nasal bone

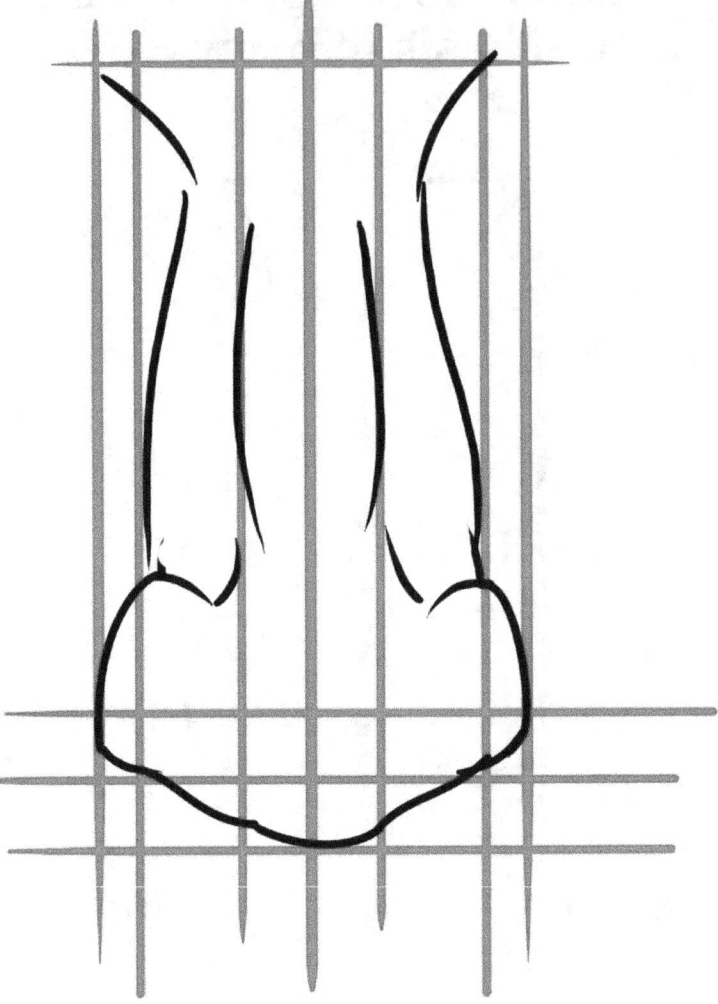

5. We're adding curves to round out the nose.

6. Now, we're adding curves for the top of the nose.

7. Add the curves that will round out the area of the nostrils.

specify the form of brow ridge, sketch the volume of nose

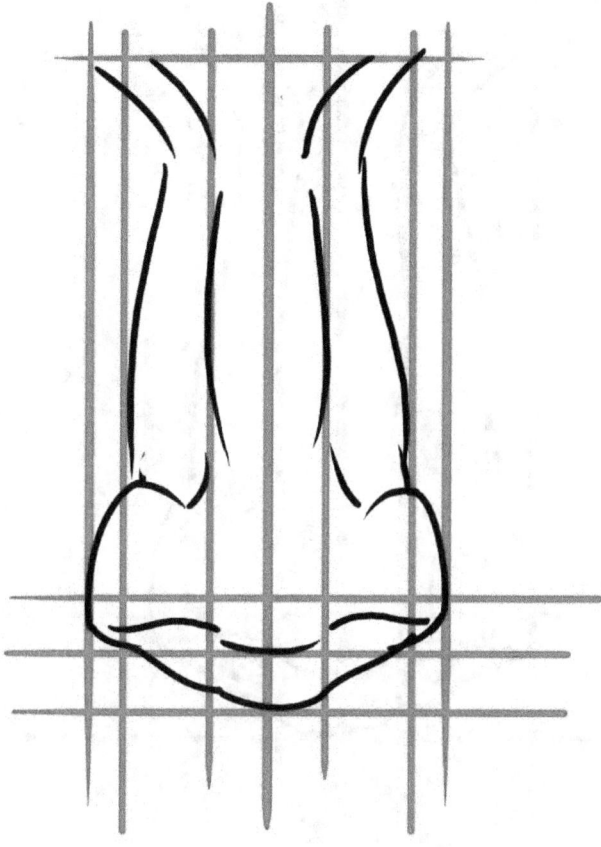

8. Here we're adding outside lines to bulk out the nose a little more.

9. We also added the curves to delineate the nostrils.

add nostrils

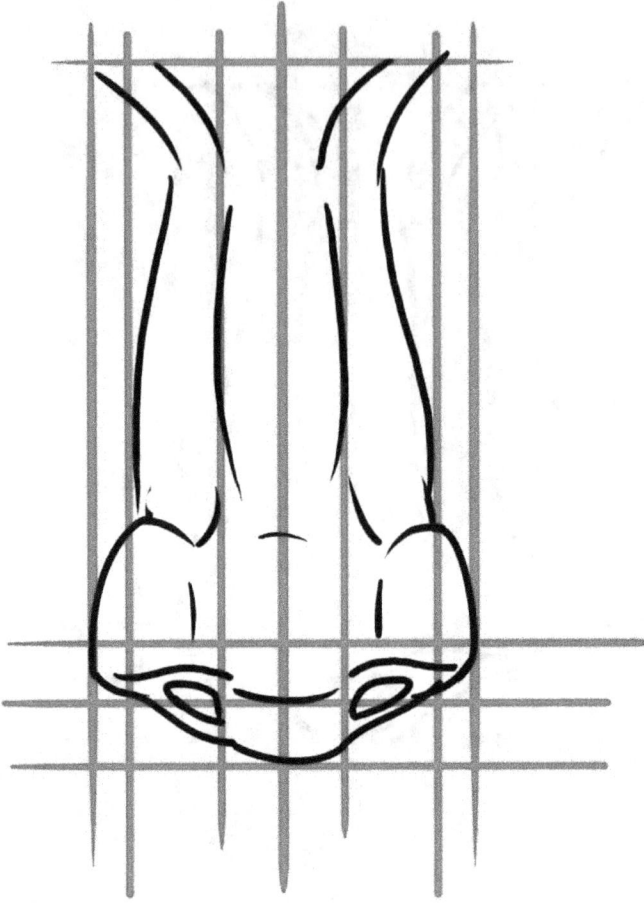

10. We highlight the nostrils a little more here. We start with the awkward circles.

11. We add dashes to further make the nostrils pop out.

12. Add the curves you see coming from the nostril area.

13. Add the shading you see in the picture.

add the shadow at the shaded pieces

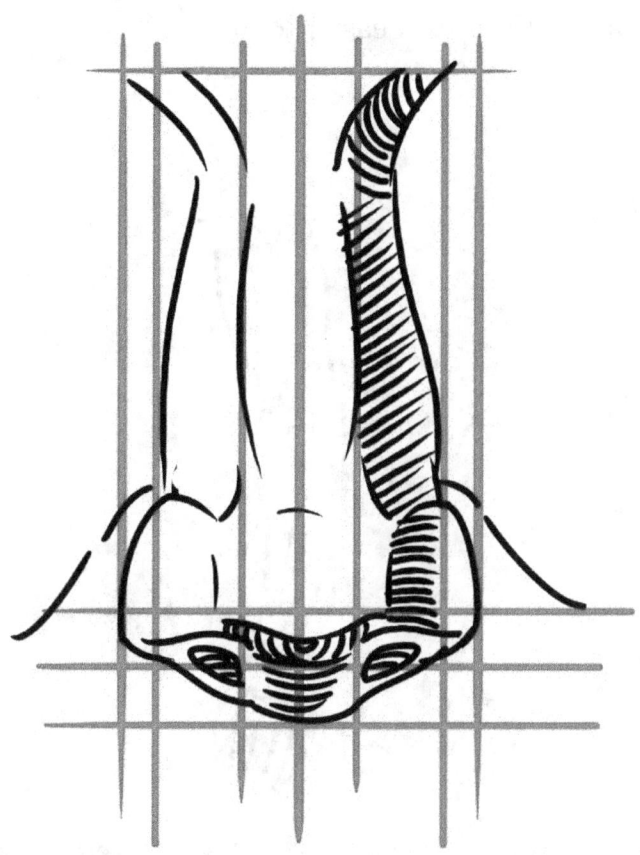

Chapter 7 – The Study of the Arm

Instead of looking at the arm as a whole, look at it as a series on interlocking curves and dashes. When we look at features and equate them with everyday shapes, it makes it easier to draw.

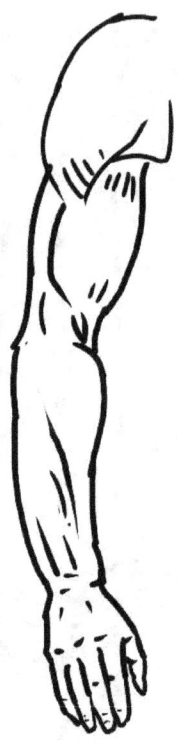

To the bottom left is the layout guide for the arm. This is one of the more simple layouts of the body. Before we use the template below, take notice of the musculature of the arm and how it is defined in the final drawing. Paying attention to these small details is what can make a piece look as if it is ready to pop off of the canvas.

form layout for arm

1. We start with the outer curve of the shoulder.

form shoulder joint

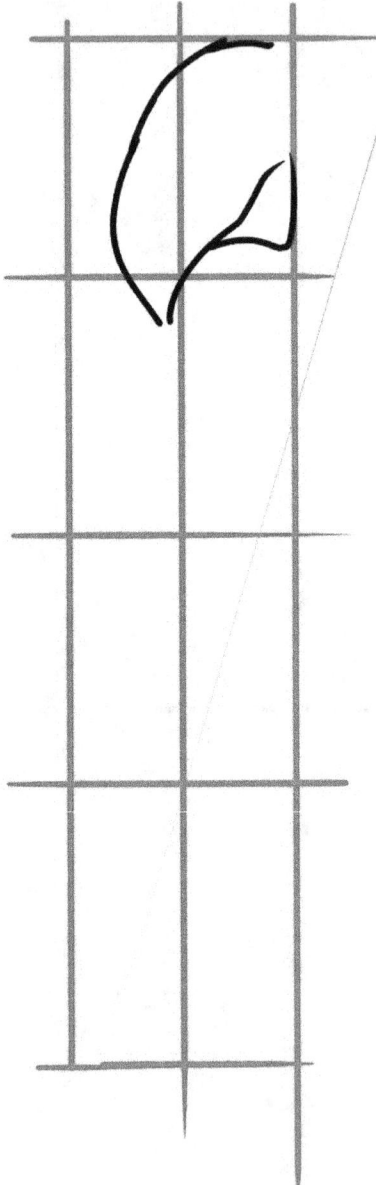

2. We now bring the curve up.

3. Add the final line in between.

add shoulder, specify biceps

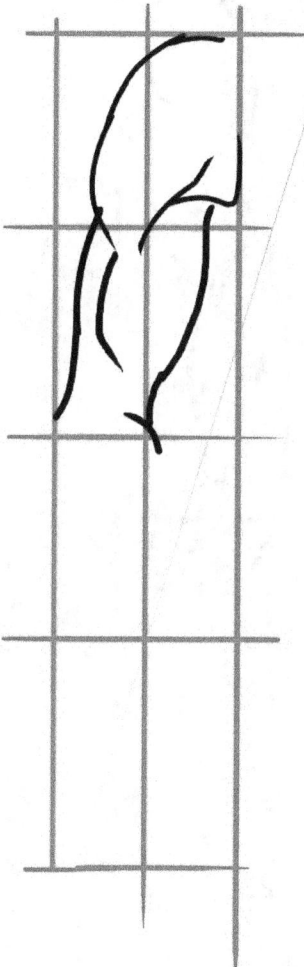

4. Draw the outer curve of the arm.

5. Draw the inner curve of the arm.

6. Draw the line for the muscle.

7. Add the small curve for the elbow.

8. In the crook of the elbow, draw a curvy "V" to highlight the elbow.

add brachia

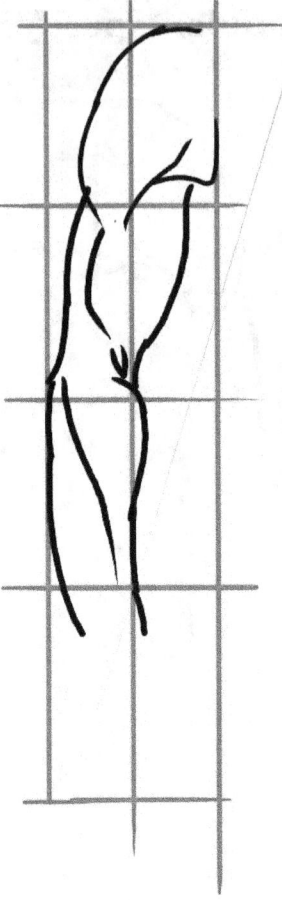

9. Add the curve on the inside of the arm.

10. Add the outside curve of the arm.

11. Add the line delineating the muscle on the forearm.

add hand

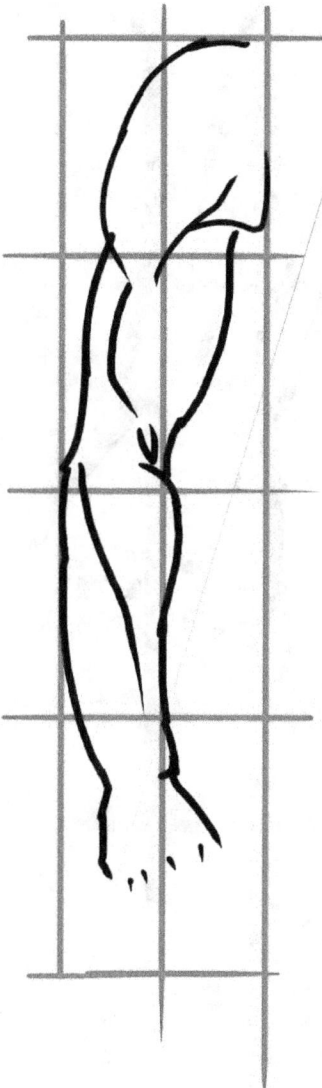

12. Add the curve of the wrist on both sides.

13. Draw the outside of my arms.

14. Add the hash marks for the fingers.

15. Add the lines coming from the wrist and going up the arm.

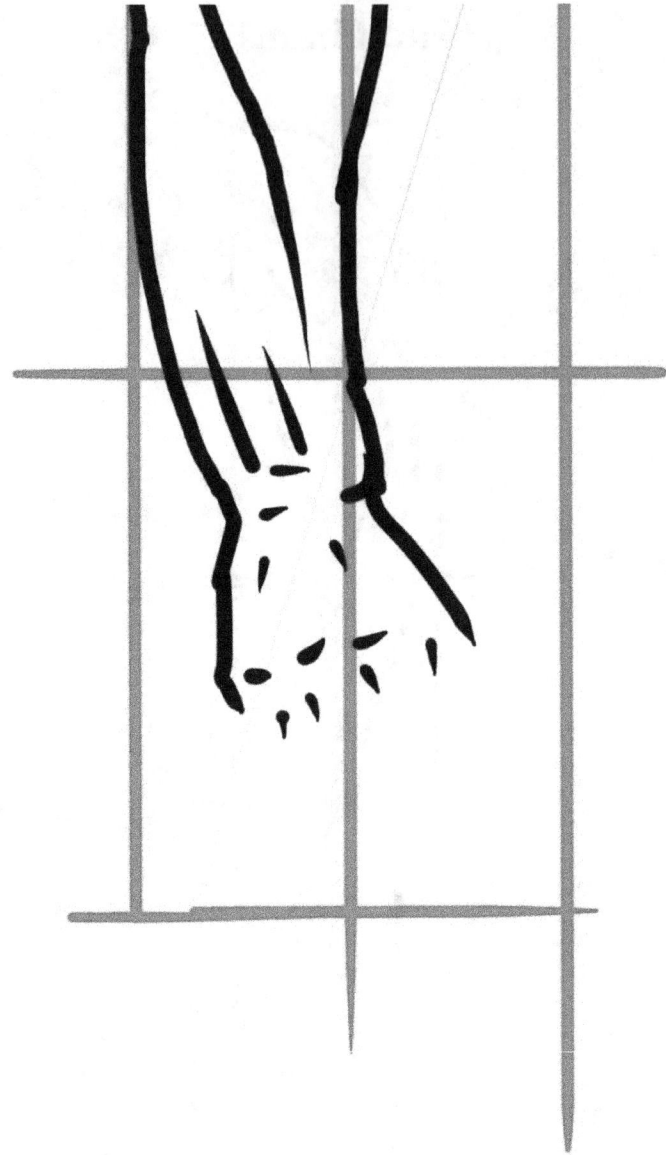

16. Add the dashed dots it the wrist area.

17. Add the accents for the knuckles.

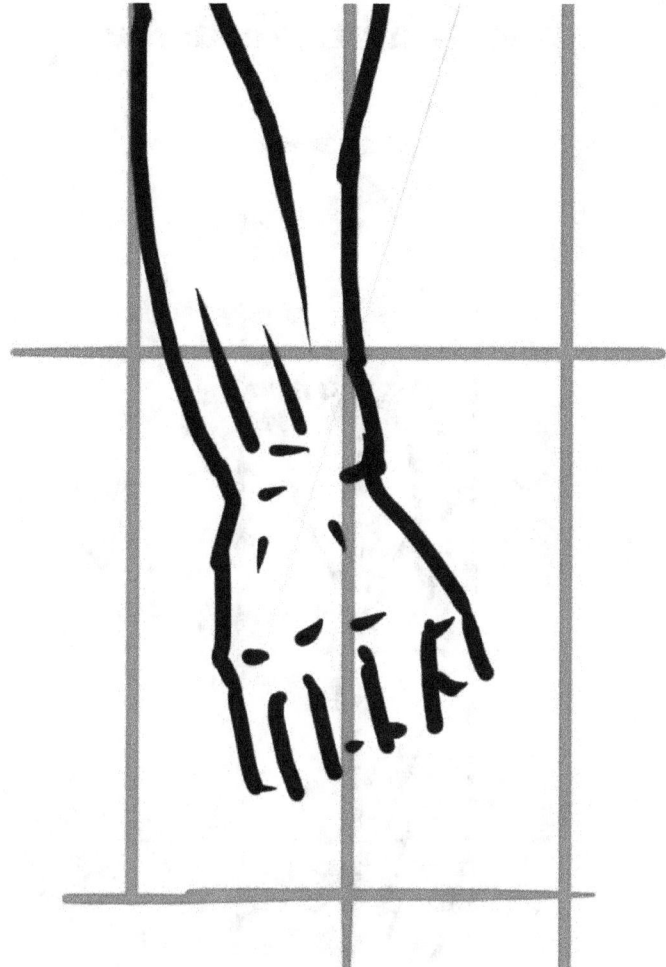

18. Draw in the small lines for the fingers.

19. Here we've finished the fingers.

20. We add dots for the knuckles.

specify arm's muscle

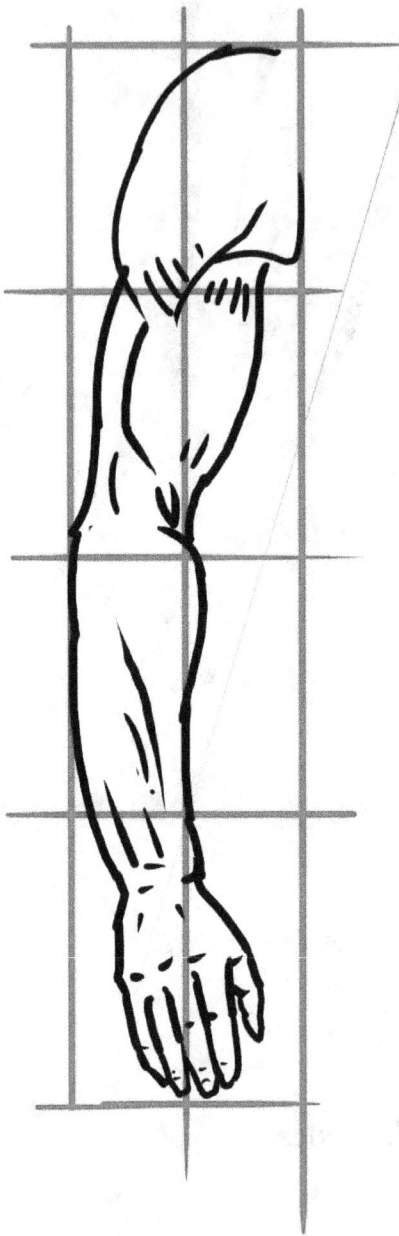

21. Finish the arms by adding the dashes to further detail the muscles of the arm.

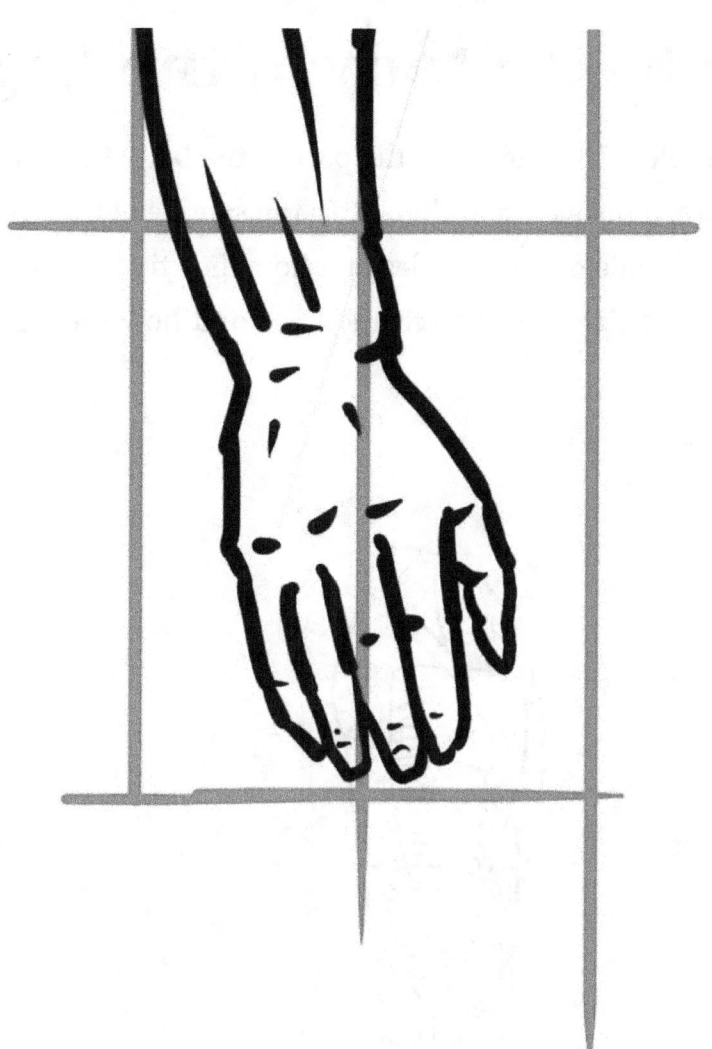

Chapter 8 - A Study of the Leg

The leg can be complex. It is, after all, the part of the body that supports all the other parts, from a physical standpoint. In the sample of the finished leg, you can see all the details of the muscles and how they tie into one another. You can see how the thigh tapers to fit the knee and how the calf muscles flair out.

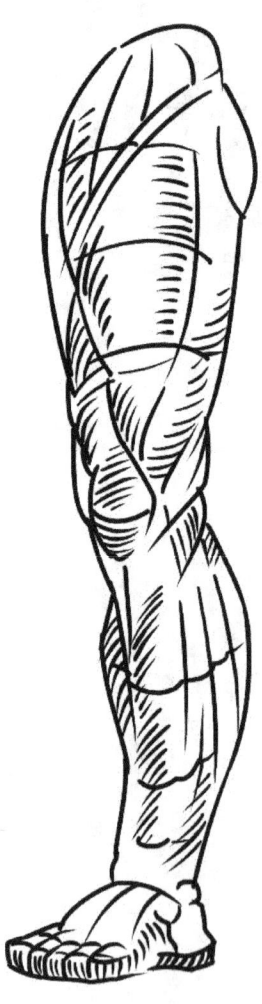

form the layout for leg

1. Draw the red guide first.

2. Starting from the top, draw your curve down and to the left.

3. Now, draw a slight bump on the right, and a slight curved line.

4. From the right, add a wide angle "L" shape and bring it to the center line of the guide.

form knee joint

5. Now, draw a bump and a slight on the left.

6. Two loosely drawn triangles make up the kneecap.

7. Draw the curves under the knee.

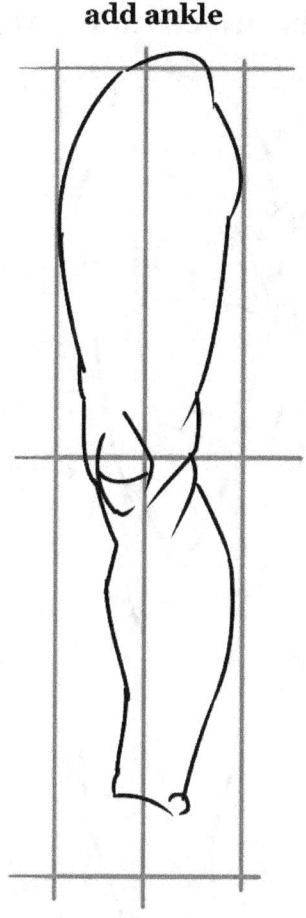

add ankle

8. Draw a wide curve on the right side that tapers in.

9. Draw the bump at the end of the taper.

10. On the left, draw a shorter curve.

11. Add a reverse curve to the first one.

12. Now add the line on the end of the leg.

13. First, draw the "V" shape you seen in the picture.

sketch muscle mass of thigh

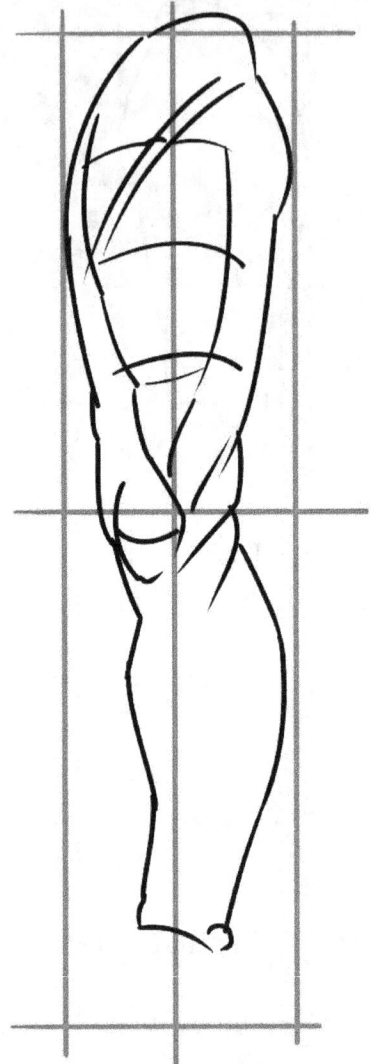

14. Draw the horizontal lines.

15. Finish with the diagonal lines.

16. Bring the line from side of the kneecap to the knee.

Compare your picture so far with what we have here. Add anything you may have left out.

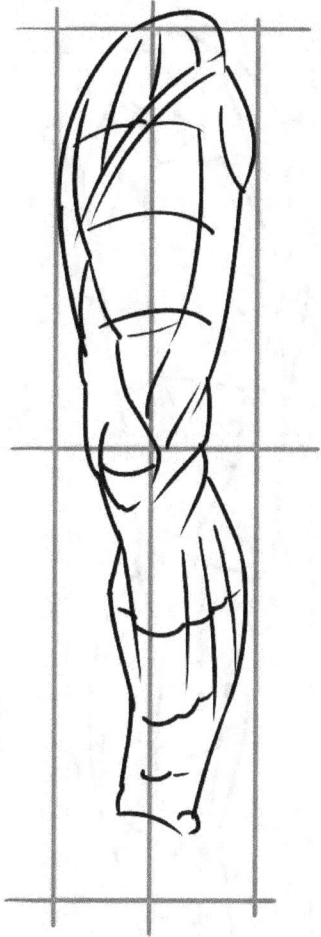

17 Under the knee, add the line vertical lines you see in the picture.

18 Now, add the horizontal ones.

19. Add the two curved lines on the thigh muscles.

20. Then, draw the curve coming up from the bump on the right side of the leg.

21. From the line on the bottom of the leg, draw a hump.

sketch muscle mass of ankle

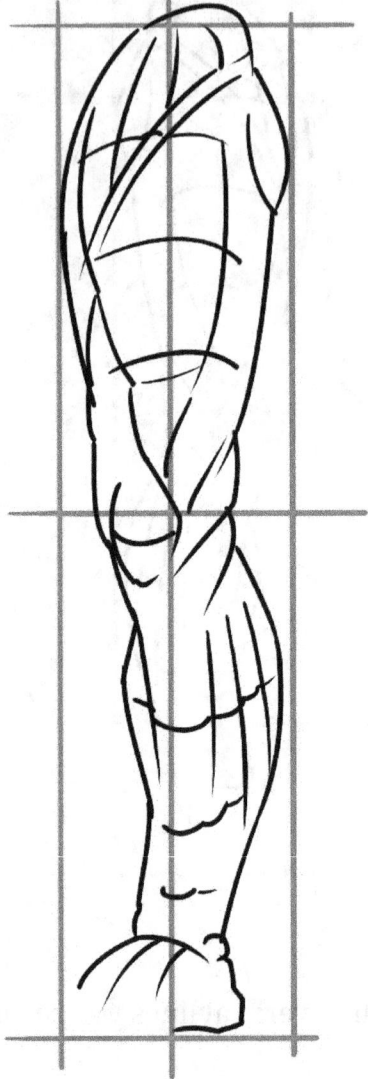

22. Add the lines you see coming from the hump.

form foot

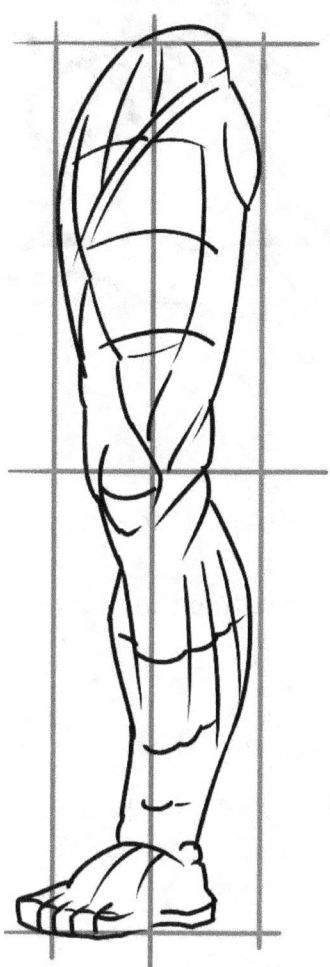

23. Add the back part of the ankle.

24. Draw left-most line coming from the back part of the foot.

25. Draw box shapes for the toes.

26. Draw the lines on the top of the foot to form the toes.

27. Draw the curve for the bottom of the foot.

28. Add any other details you may be missing.

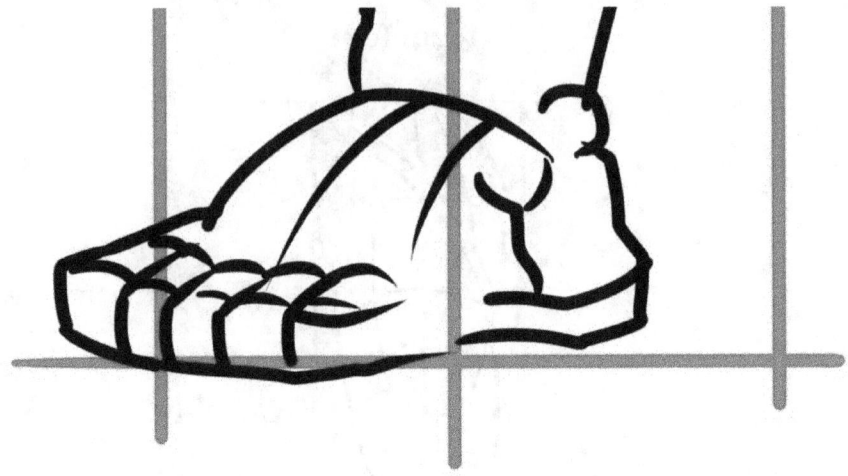

29. Finish out the foot by detailing the toes as you see here.

30. Using hash marks, further define the muscles as you see here.

specify muscles

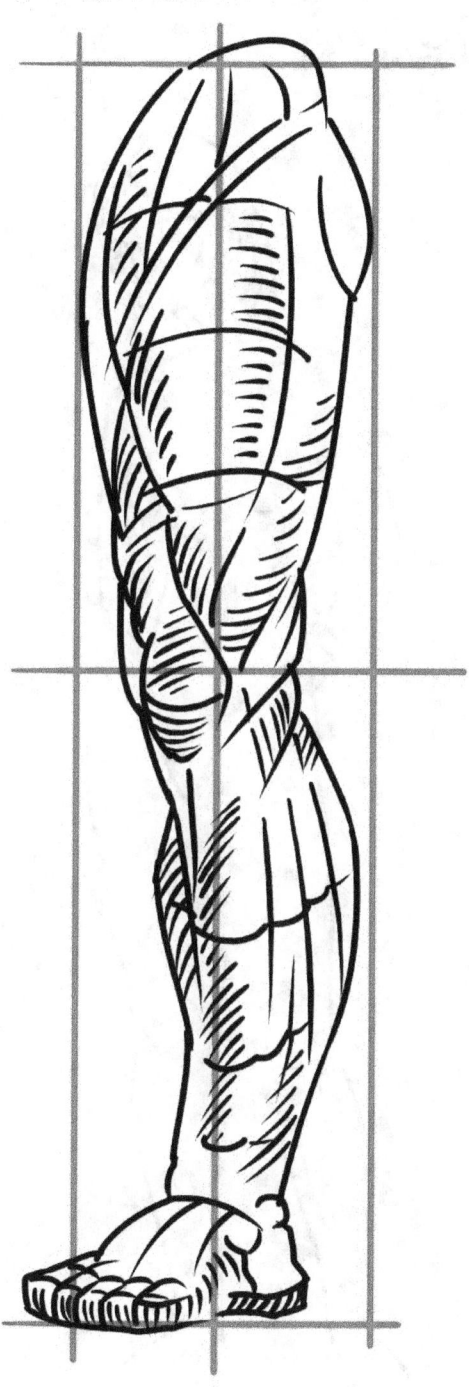

Chapter 9 - A Study of the Female Figure

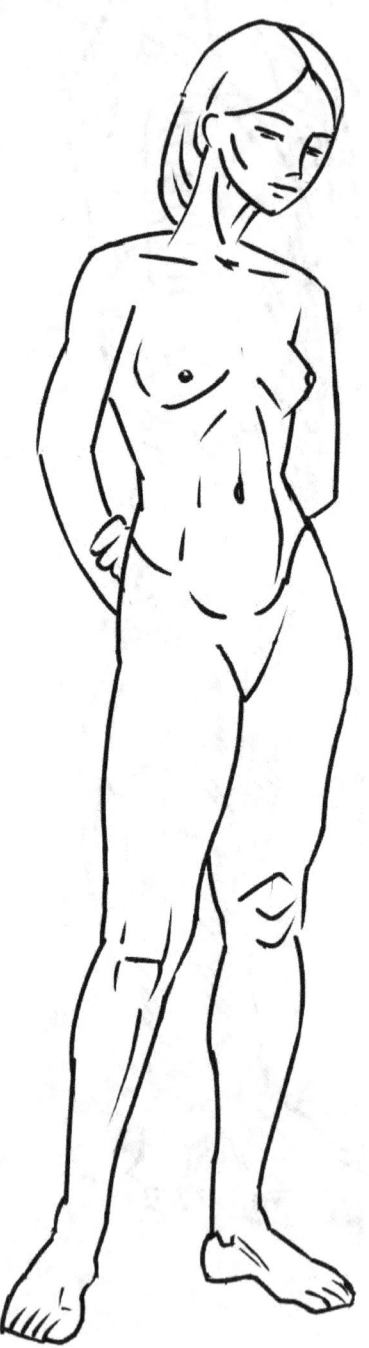

We've studied the basics of shading and formatting. We've delved into drawing the individual parts of the body. Now, that we've done all of that, we are moving into the form in its entirety. We're starting with the female form because it is the more difficult of the two genders to study in art and drawing.

1. Draw the layout on the left.

form layout for female figure

2. Using the layout for your guide, draw the lines you see in the diagram. This is the groundwork for the body and will help you flesh it out better.

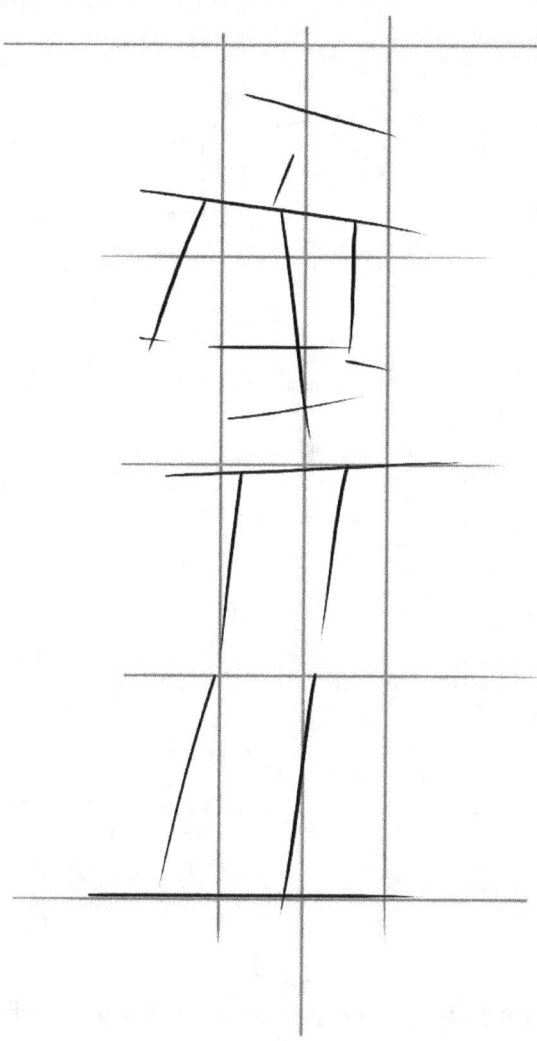

sketch neck, arms and legs

3. Draw the dome of the head.

sketch the form of head and form feet

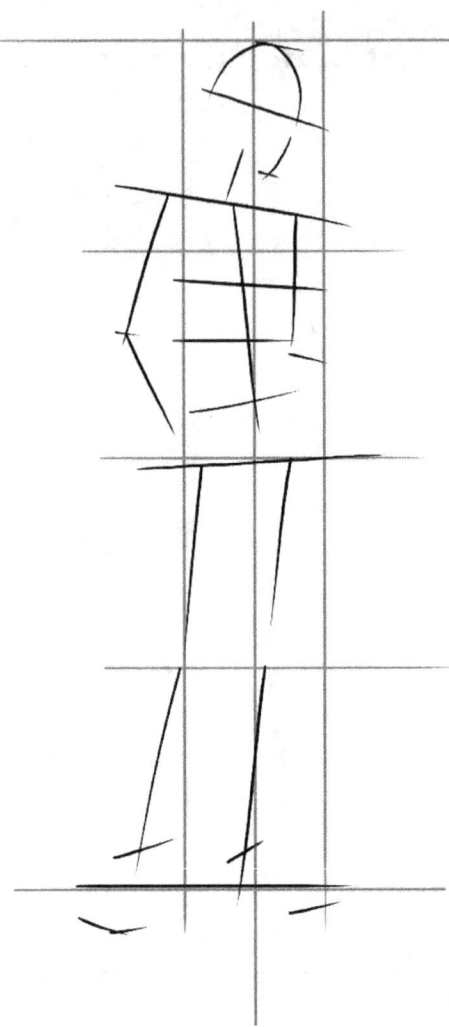

4. Add the face and chin area, remember, it's a rough sketch at this point.

5. Now, add the lines for the feet.

sketch facial features

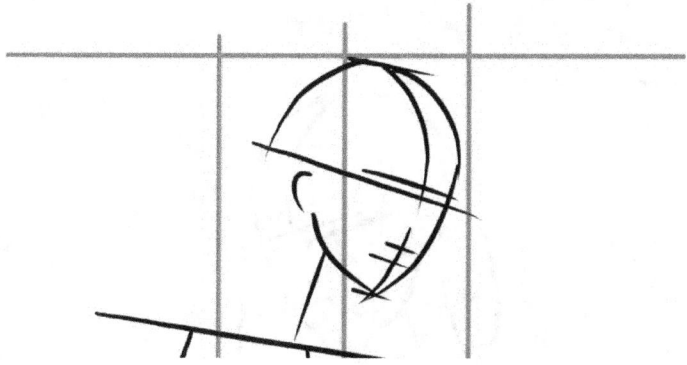

specify the form of hair

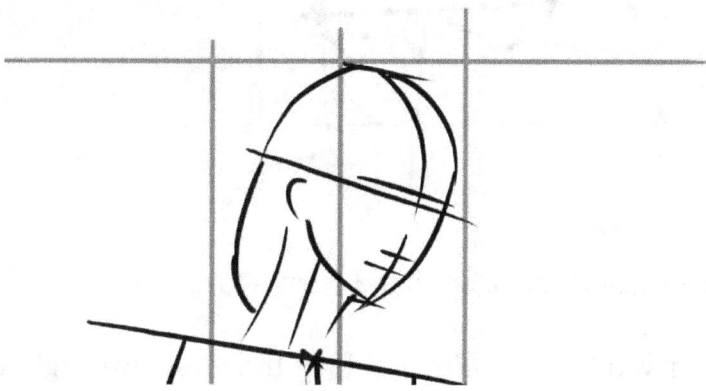

6. I've zeroed in on the face to make it easier to follow. Sketch out the rest of the face by drawing jaw line first and then the dashed for the facial features.

7. Sketch in the hair.

sketch the form of breast

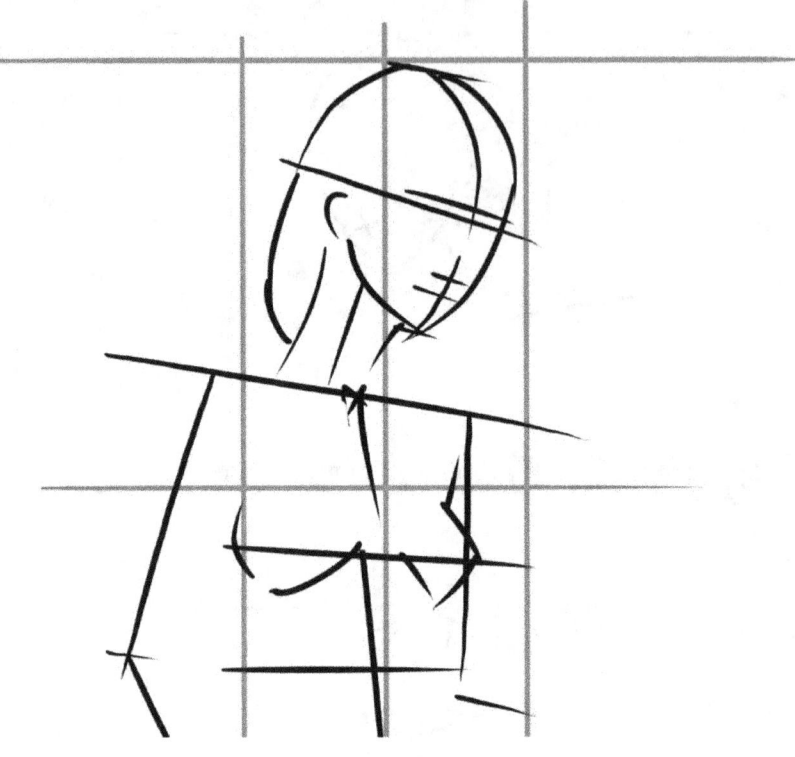

8. Using the layout, add the dashes and curves for the breasts.

9. By drawing curved lines on either side of the torso, we begin to sketch out the arms.

specify the form of arm

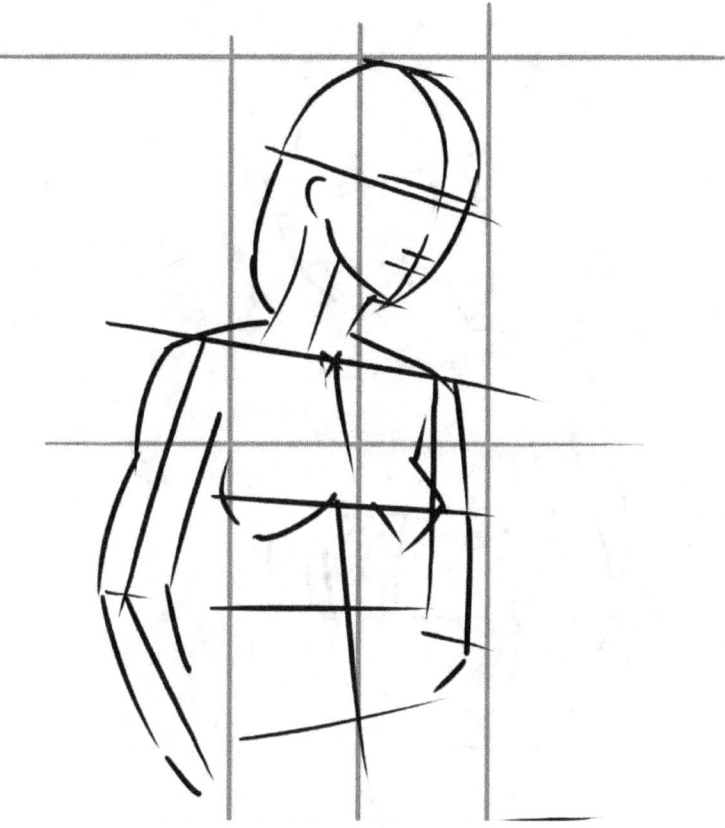

10. We're defining the muscles of the torso here.

specify the form of body

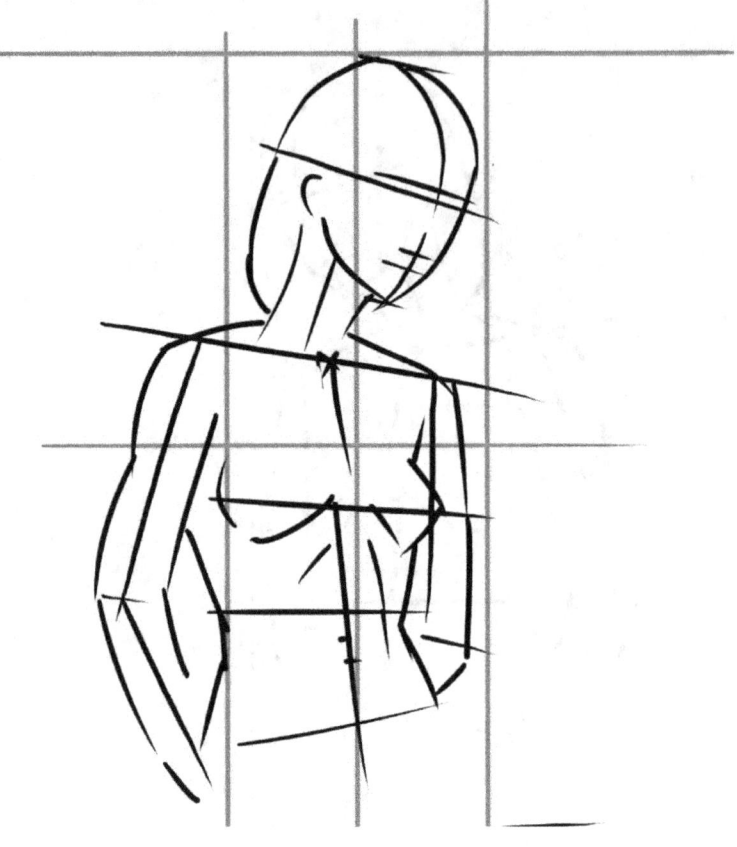

form prelum

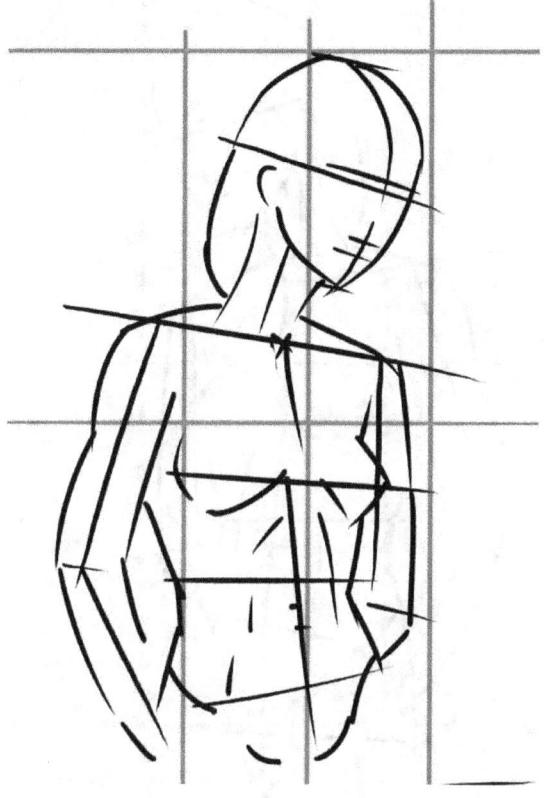

11. We are defining the hip area by making the curve before introducing the legs.

12. Add the nipples to further define the breasts.

detail the breast

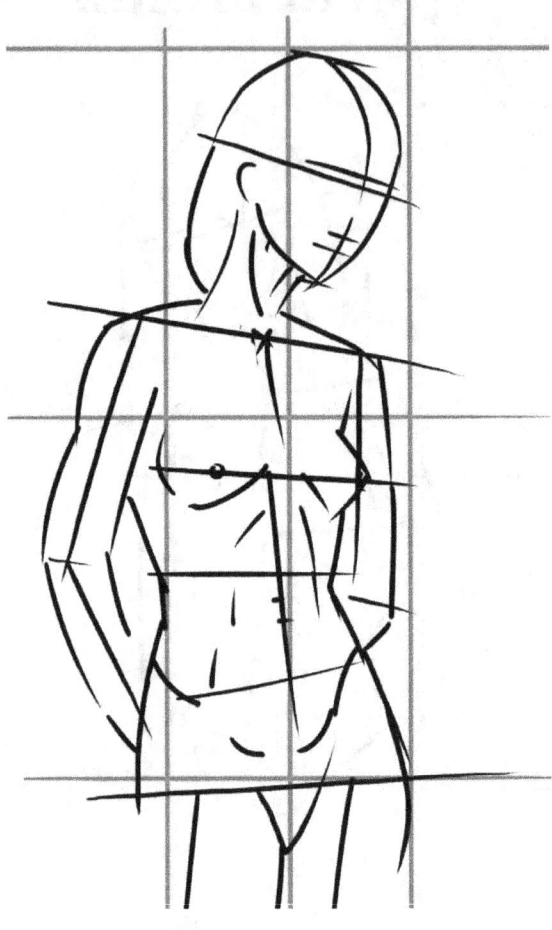

13. We are also adding the curves for the outside of the hips.

14. We are adding the curved "V" for the vaginal area.

15. Now, add the curves for the inner thighs.

sketch the form of thigh

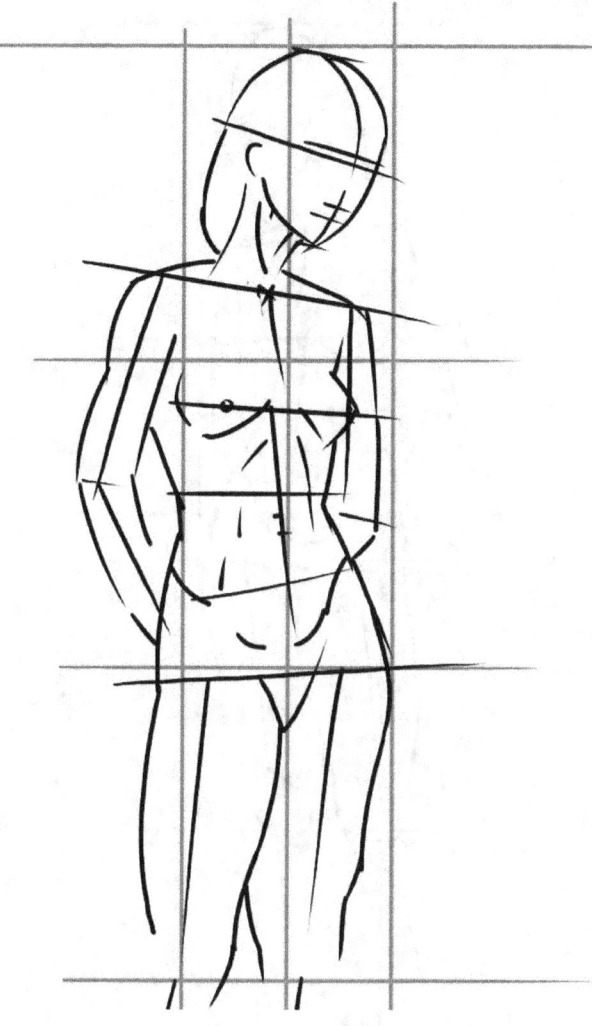

16. We're bringing the curves of the legs down, both the inner and outer portions of the legs.

form knee joint

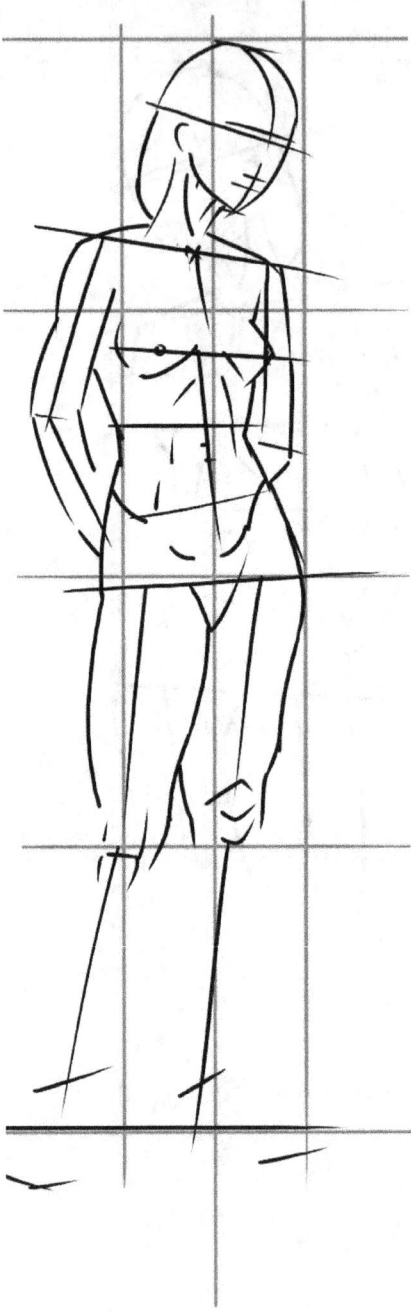

17. Starting on the right, add the slight curve for the outside of the leg.

18. Add the "V"s to outline the knees.

19. Add the lines on the inner leg.

20. The left leg has another curve to start the knee.

21. We've added half-squares for the knee in this case.

22. Add the curves for the calves of the legs. It's easier if you start from the outer part of the right leg and work your way to the outer side of the left leg.

form ankle

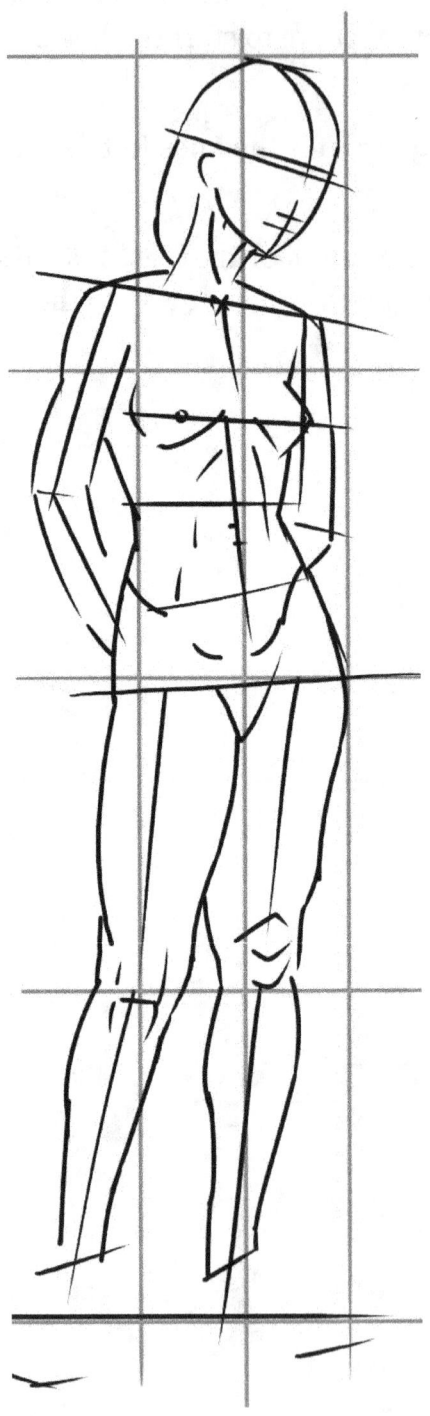

23. Start from the slant where the leg stopped and draw the back curve of the right foot.

24. Now, draw the curve for the top of the foot.

25. Add the bottom of the foot.

26. Start with the inside of the left foot.

27. Round out the front of the foot.

28. Bring the curve back up to the ankle.

29. Add the lines for the toes.

30. Add the details on the tops of the feet.

31. Add the dashes for where the eyes are going to go.

detail facial features and hand

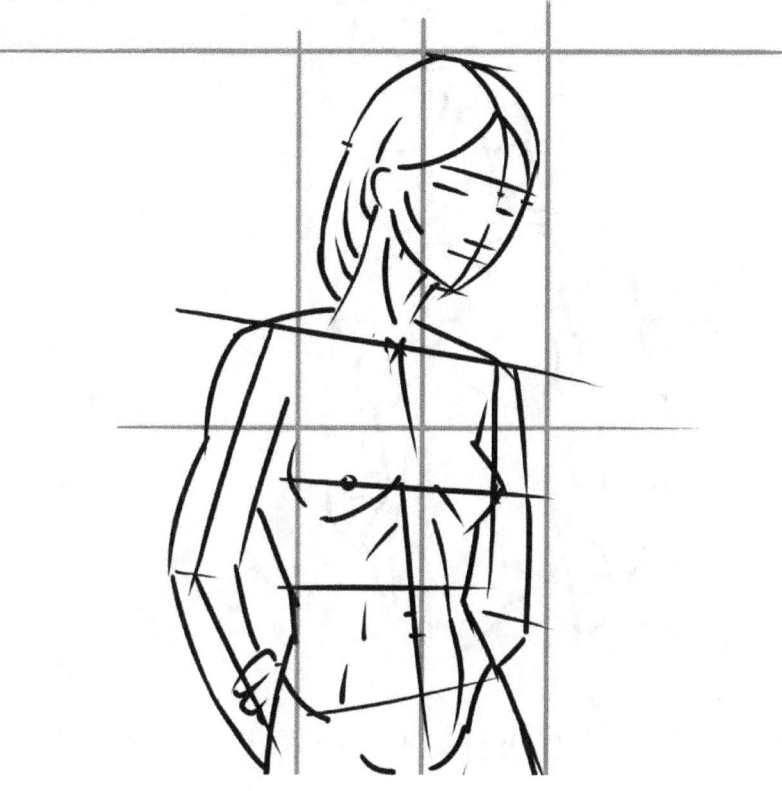

32. Define the cheekbone.

33. Add the curves for the fingers of the hand.

form collarbone

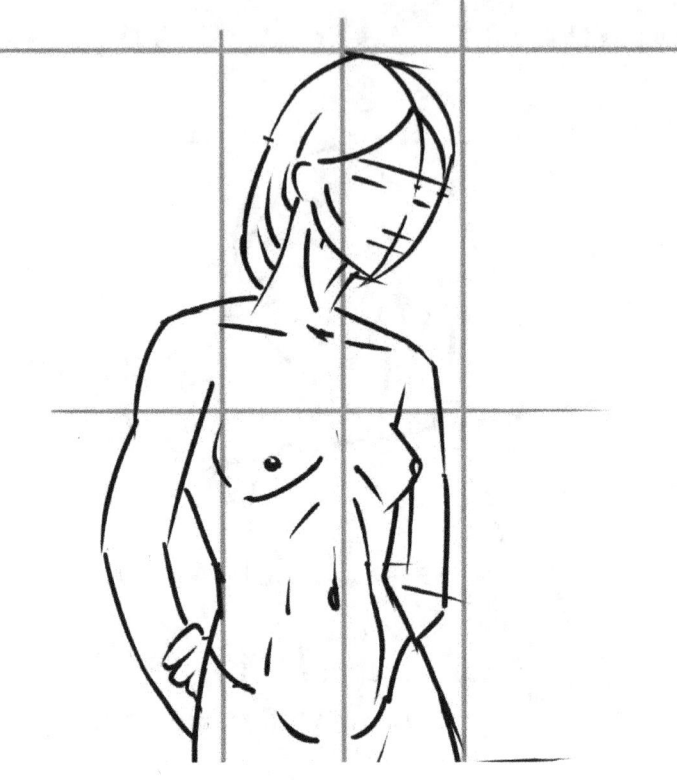

34. Clean our subject up by removing the guides for the shoulder and breast area.

35. Add the lines for the collarbone.

 Now would be a good time to compare what you've done so far with what is to the left.

36. Remove the rest of the lines we've used as a guide.

37. Add the details for the eyes. Keep in mind, the eyes here cannot look as detailed as in a previous lesson. The head is too small for that.

38. Add the nose.

39. Add the lines for the mouth.

40. Add the details for the hair.

Take one last time to look everything over before going on to the next lesson. Don't worry if it's not perfect. One does not become a master artist overnight. It takes practice, repetition, and dedication.

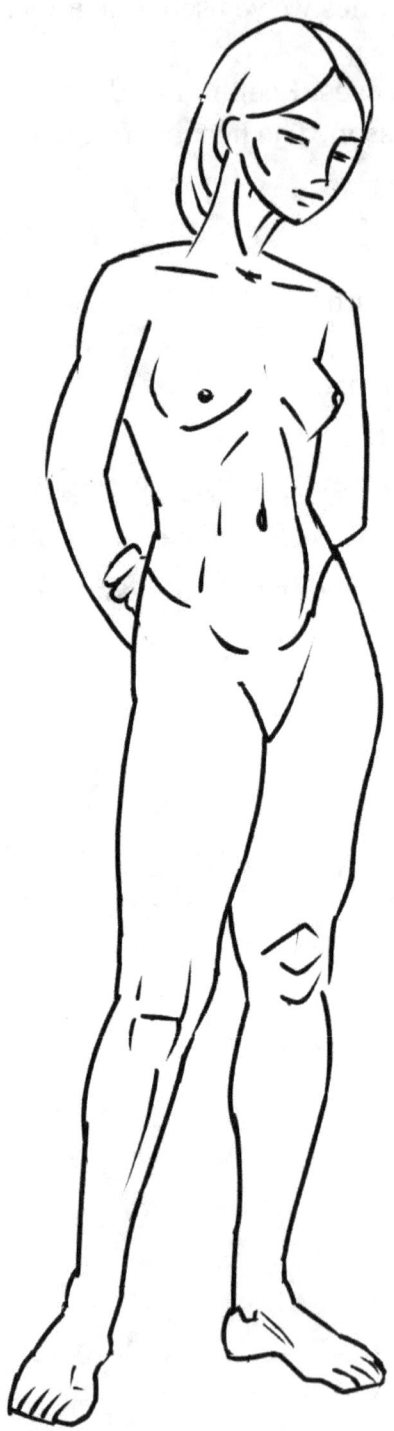

Chapter 10 - A Study of the Male Form

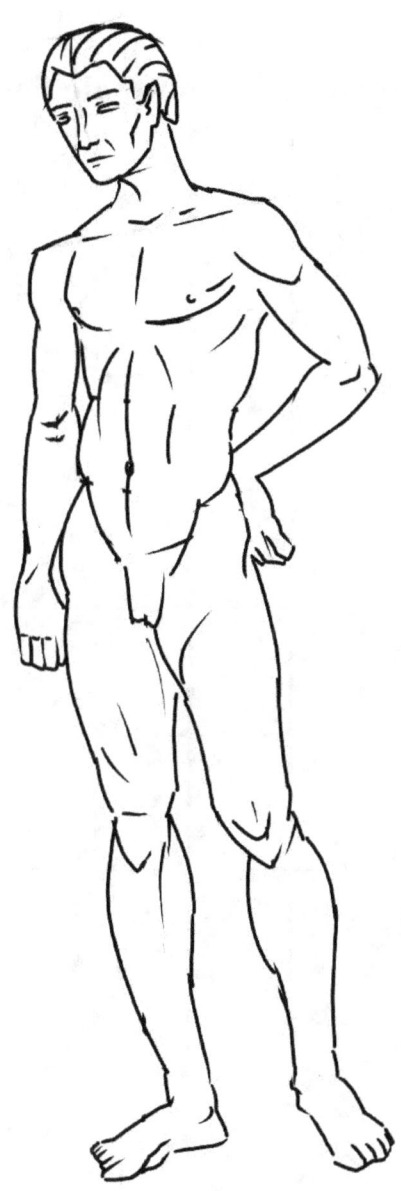

We can see, by comparing the two forms, the male figure is more blocky in appearance. This makes the male form easier to draw as a subject. Unlike the female form, the male form has delineations for the breasts and less curvature.

form layout for male figure

1. Start out with the layout as we did for the female figure.

sketch main construction line

2. We now add the construction lines to help us fill in the details later.

specify facial features and feet edge

3. Add the guidelines for the face and feet.

4. Add the sketch lines for the torso.

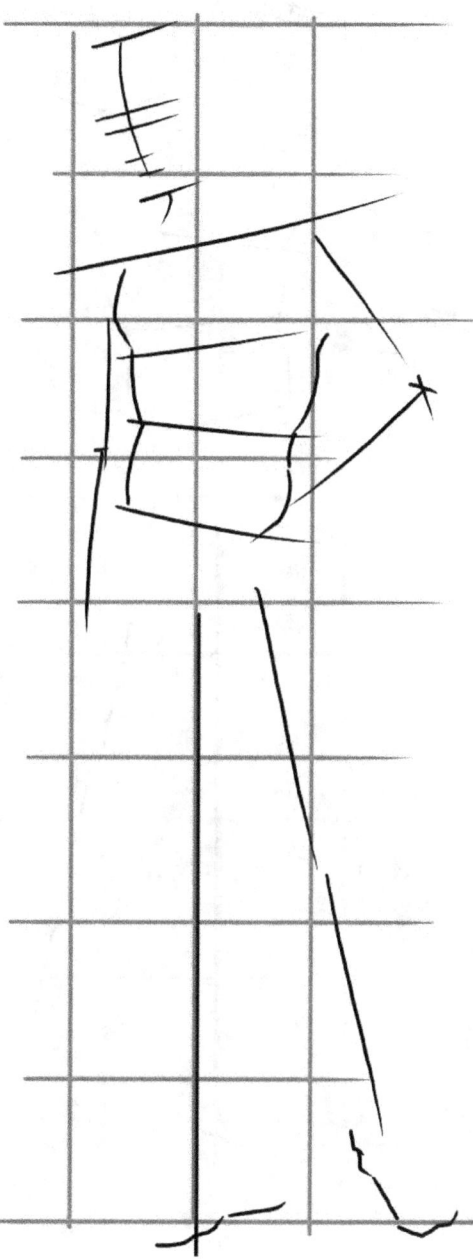

sketch body

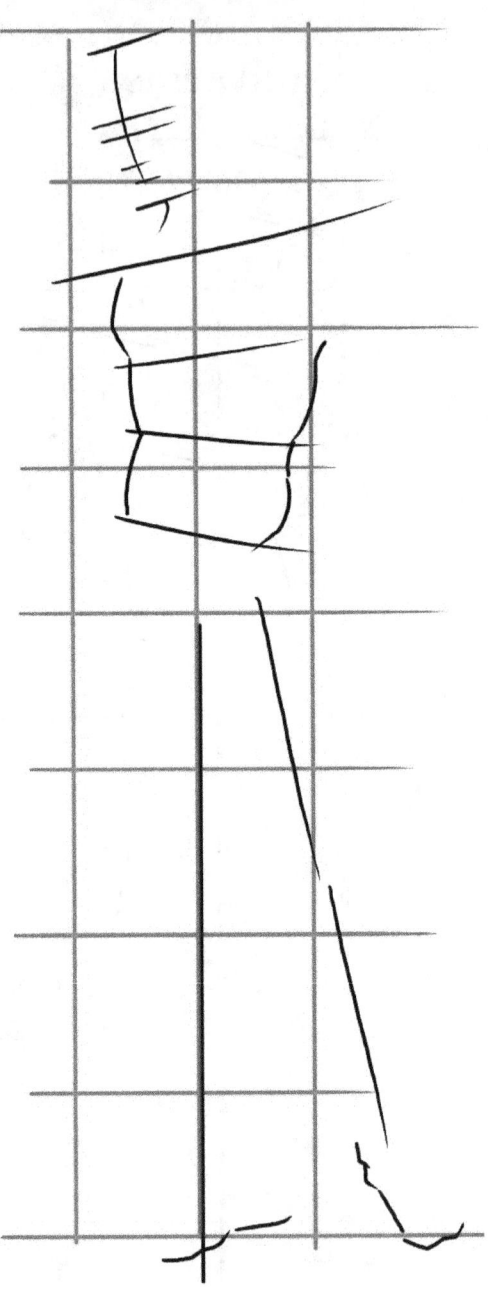

5. Add the sketch lines for the arms.

6. Now, add the lines for where the hands are going to go.

sketch prelum and intima

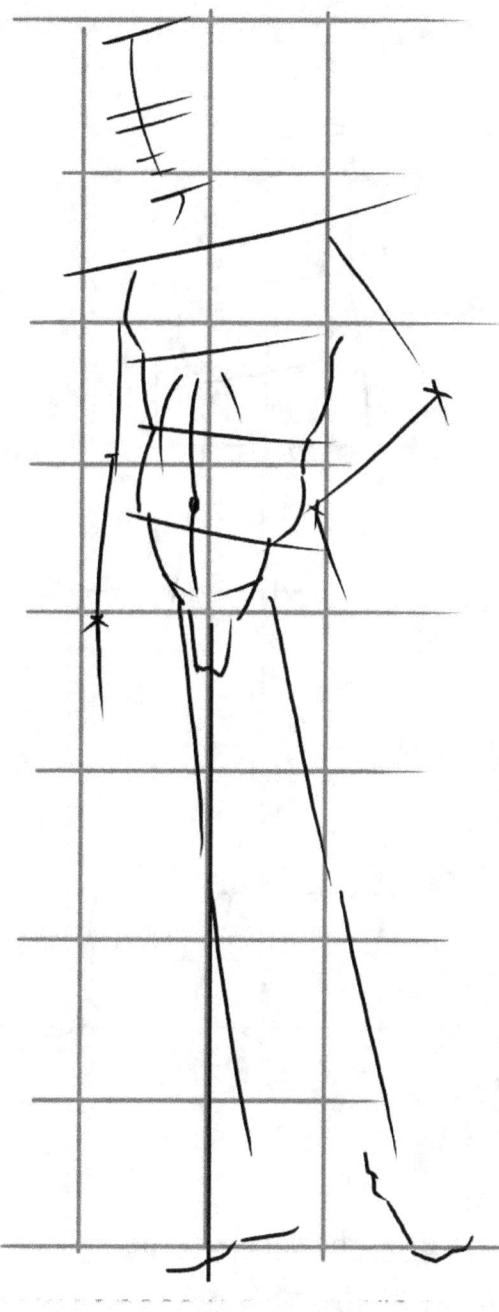

add hands

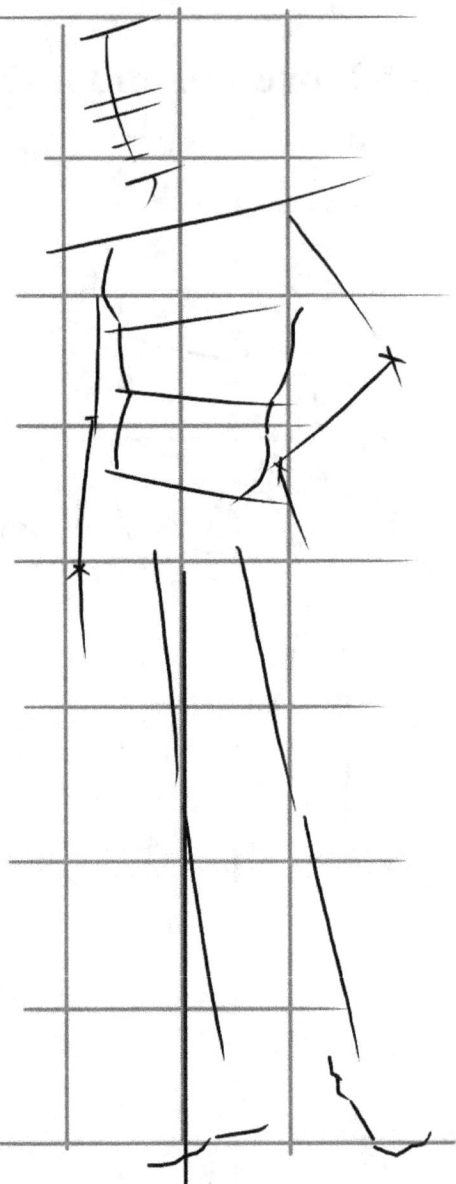

7. Starting on the left, draw the curves of the torso.

8. Do the same for the right side.

9. Now, draw the curves in the pelvic area and add the penis.

10. Define the muscles in the mid-section.

11. Don't forget the belly button.

add chest muscles

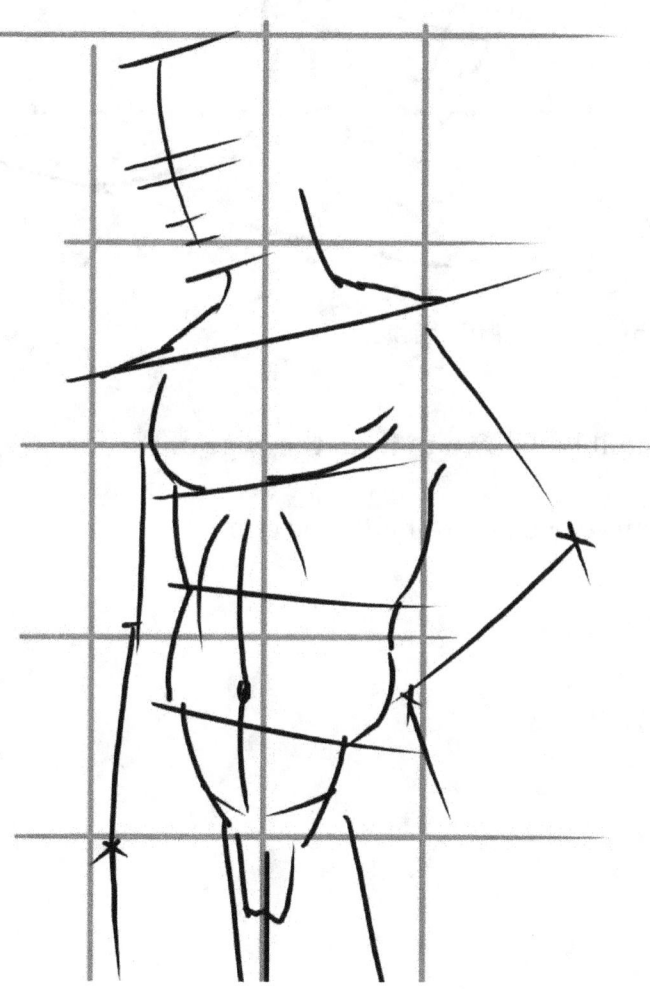

12. Add the lines for the breast area.

13. Add the curves for the neck and shoulder areas.

create brainpan

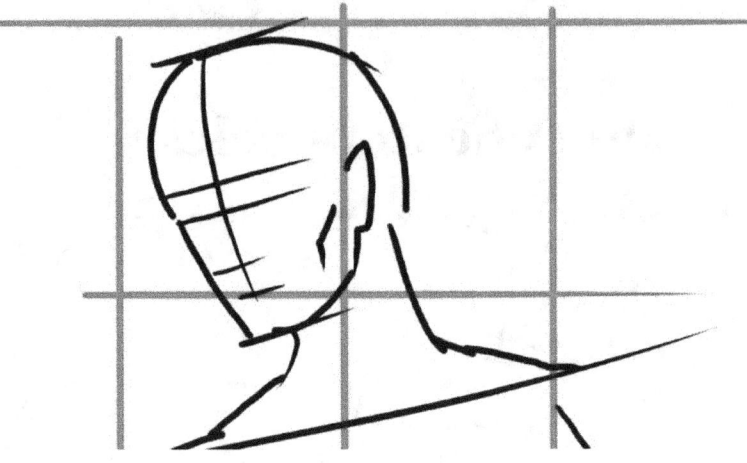

14. Draw the top of the skull first.

15. Bring the skull line down to form the edge of the face.

16. Bring the curve back up to make the chin.

add thigh and knee joint

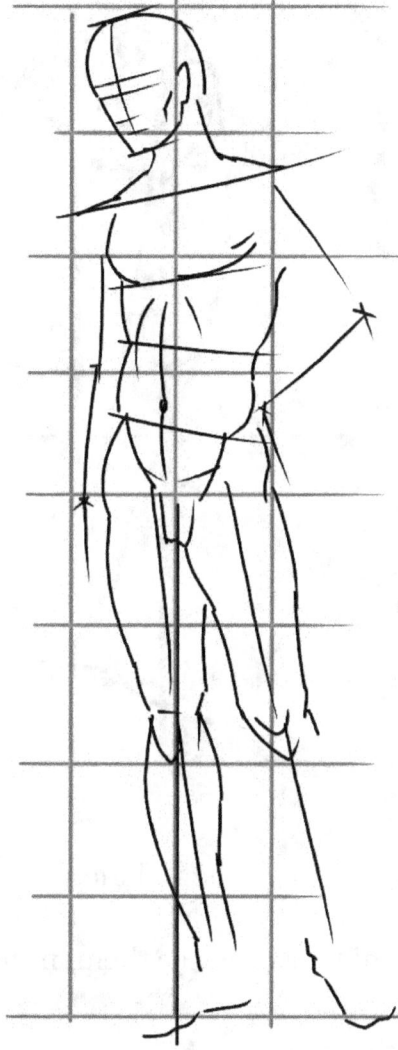

17. We're bringing the curves down out from the hip area to the thigh on the right leg first.

18. When this is finished, draw the inner thigh of the left leg.

19. Draw the outer thigh of the left leg.

20. Sketch in the lines for the knees.

21. Now, bring the lines down on the left to start the calf.

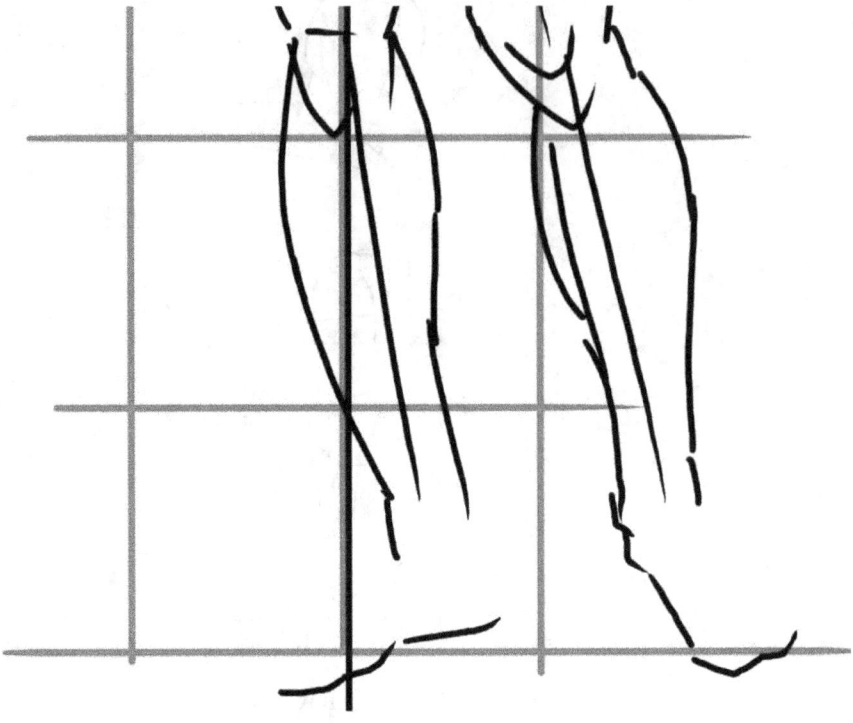

22. Bring the curve down on the right leg.

23. Now, add the ankles as you see them in the picture.

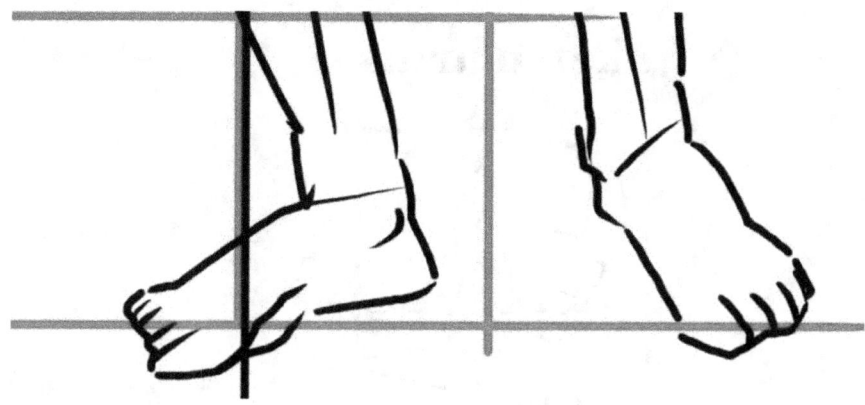

24. The next step is to finish the curves of the feet.

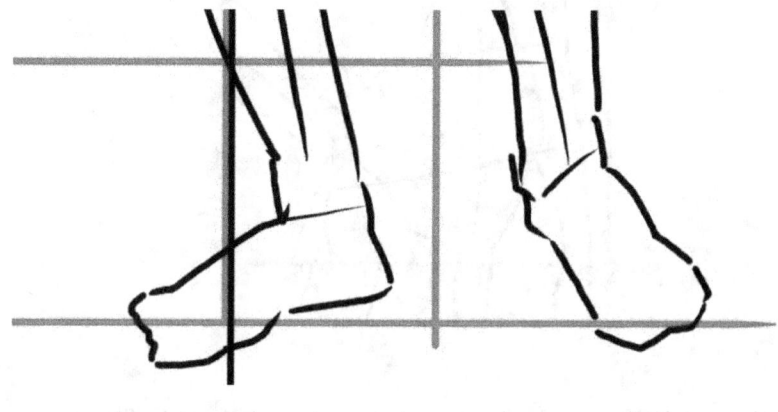

25. You can't have feet without toes. Add the small curves for the toes on each foot.

sketch arms

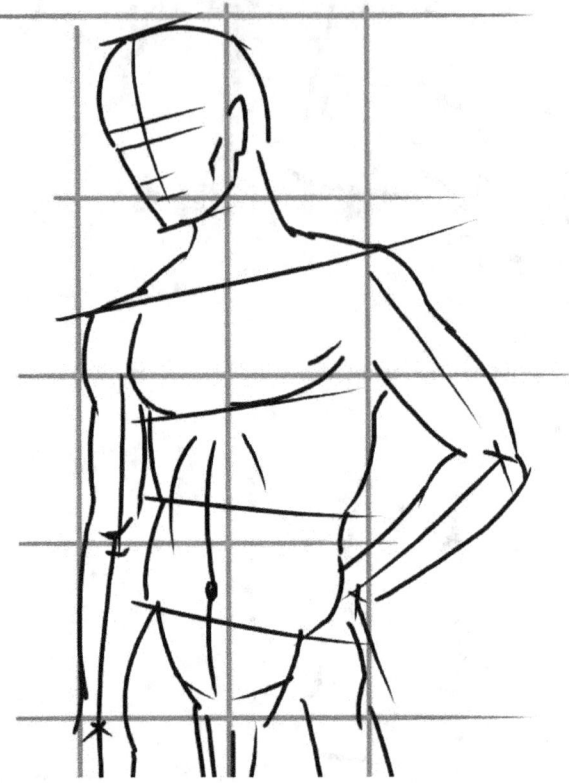

26. Following the lines you've put as guides, add the curves of the arms from the shoulder line to the elbow. Do this for both arms.

27. Now, add the lines for the forearms.

Take this time to compare your drawing the one on the left. Don't worry if it's not exact. You're still practicing.

28. After adding the arms, start on the curves for the fingers on the right hand.

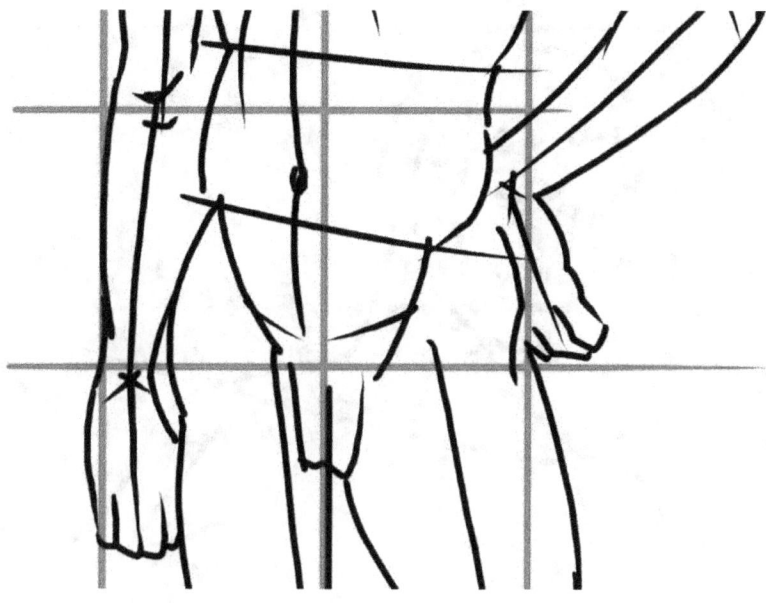

29. Draw "L" shapes for the fingers on the other hand.

specify facial features

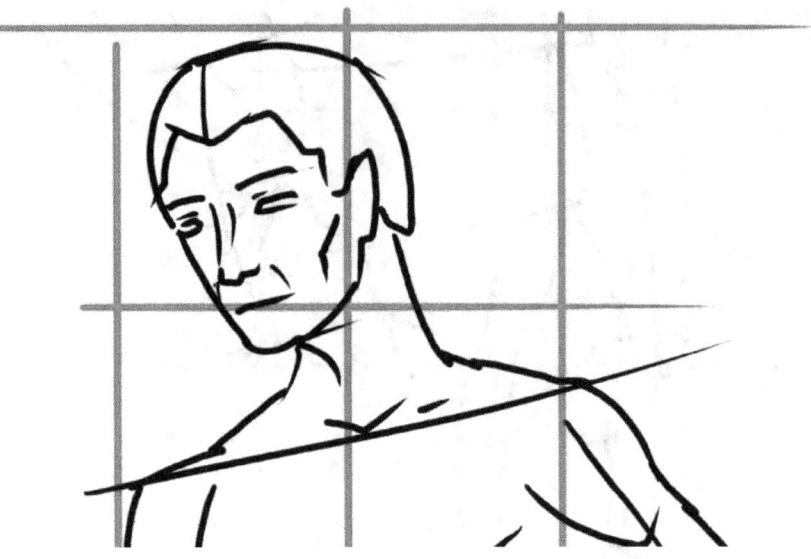

30. Add the details to the face you see to the left. Take your time. It's best to start with the eyebrows and work your way down the face.

add hair

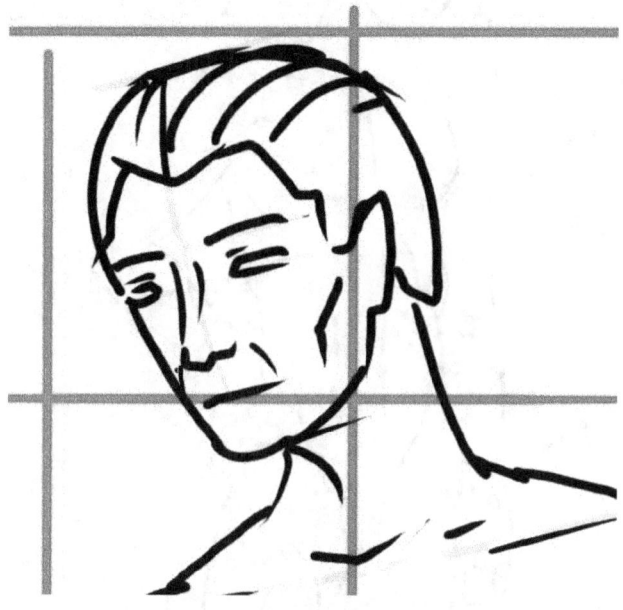

31. Slight curves tell us where the hair is.

32. Remove your lines and compare pictures.

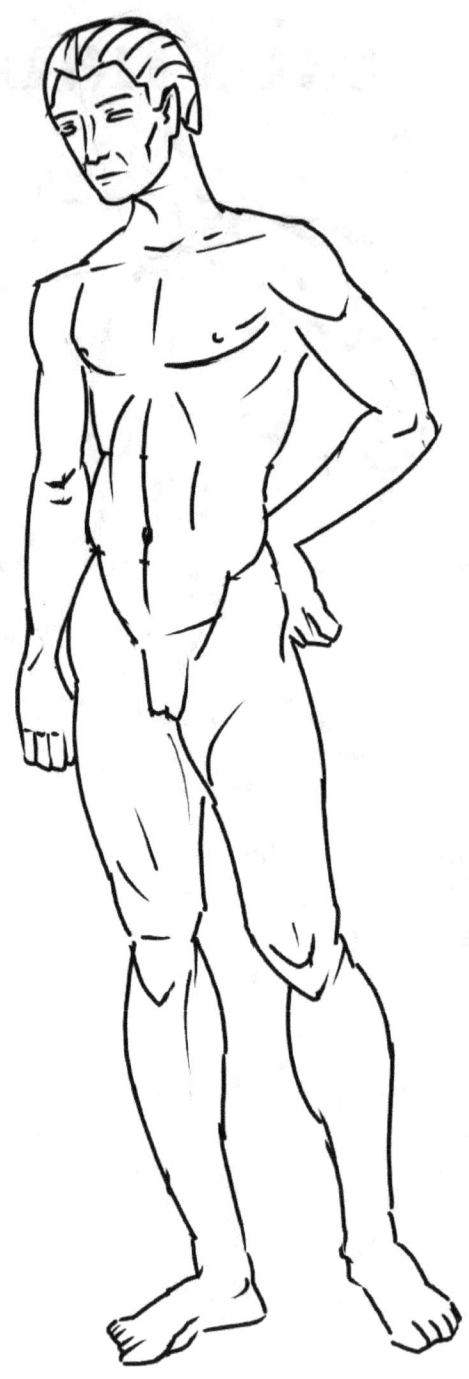

Final Words

You can go back and redo these lessons until you are comfortable with the technique. Work at your own pace and compare your recent work with your past work. Don't worry about how the other artists are doing. Everyone has their own individual style, and you will find yours with time.

I hope this books has answered you've had and even helped you improve your skill.

Thank you!

Thank you for choosing our book, we hope you found it interesting and helpful.

If you liked the book, please give us a favor to write your review.

We would really appreciate this!

If you would like to have a bonus – **FREE BOOK**, please send the screenshot of your review to this e-mail: **gloria.kemer@gmail.com** and we will send you a **FREE BOOK** in PDF as a **GIFT!****

Hope to see you in our future books and good luck in your drawing experience!

**** in the e-mail subject please mention the name of the book you reviewed and the author.**

www.ingramcontent.com/pod-product-compliance
Lightning Source LLC
Chambersburg PA
CBHW081157180526
45170CB00006B/2108